Illin Impressions

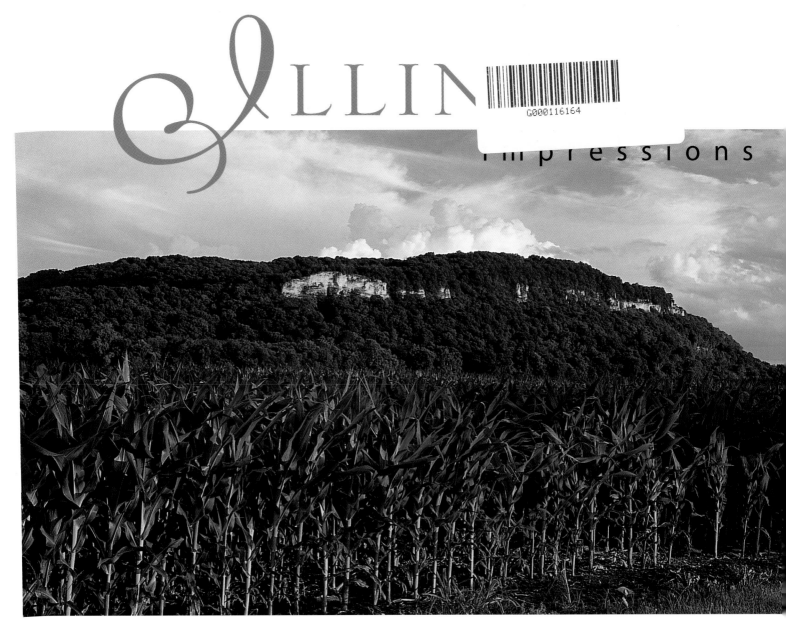

photography by Scott R. Avetta

FARCOUNTRY PRESS

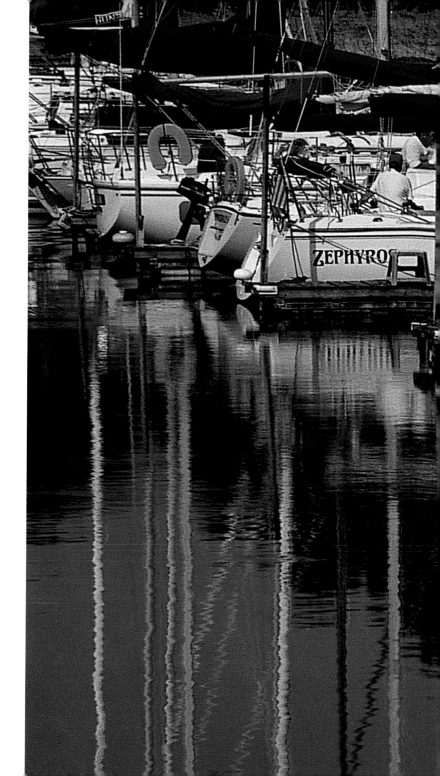

Right: Marina at Carlyle Lake.

Title page: Corn crop and Mississippi bluffs, Madison County.

Front cover: Sugar Creek, Sangamon County.

Back cover: Green Heron, Horseshoe Lake.

ISBN: 1-56037-281-8
Photographs © 2004 by Scott R. Avetta
© 2004 Farcountry Press

For more information on our books write: Farcountry Press, P.O. Box 5630, Helena, MT 59604; call (800) 821-3874; or visit www.farcountrypress.com

Created, produced, and designed in the United States.
Printed in China.

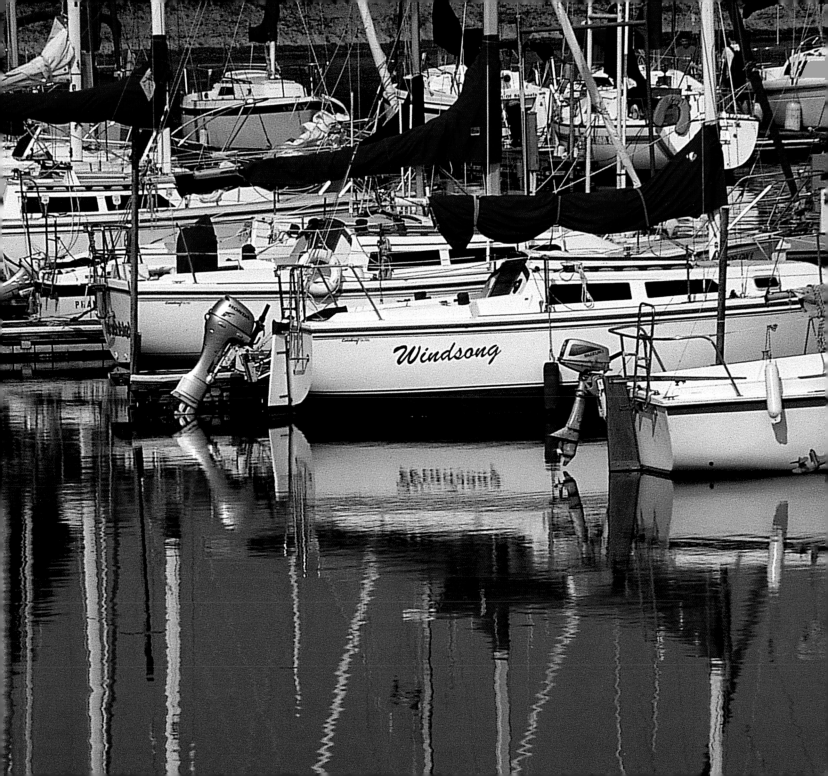

Following pages: Clarence Buckingham Memorial Fountain and Garden, the centerpiece of Chicago's Grant Park.

Right: A Grafton harvest of pumpkins and gourds.

Below: One of the famed albino squirrels of Olney, protected by city ordinance and state law.

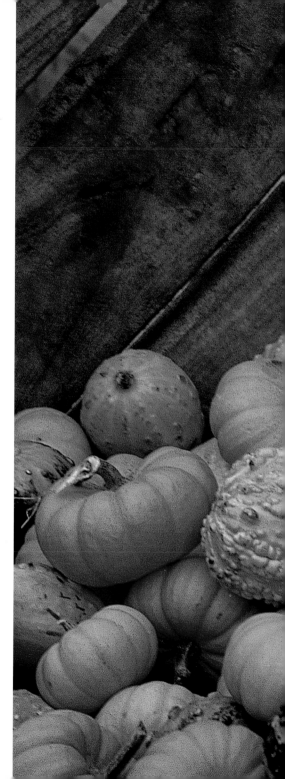

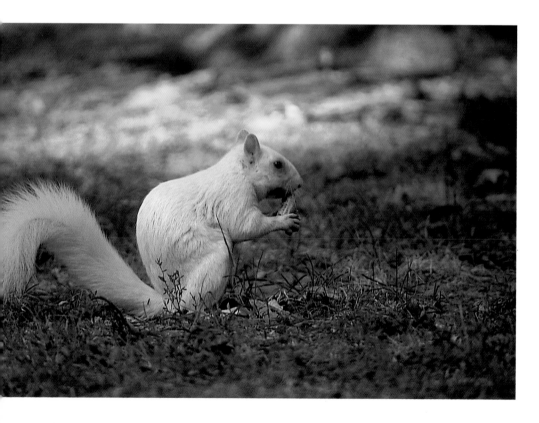

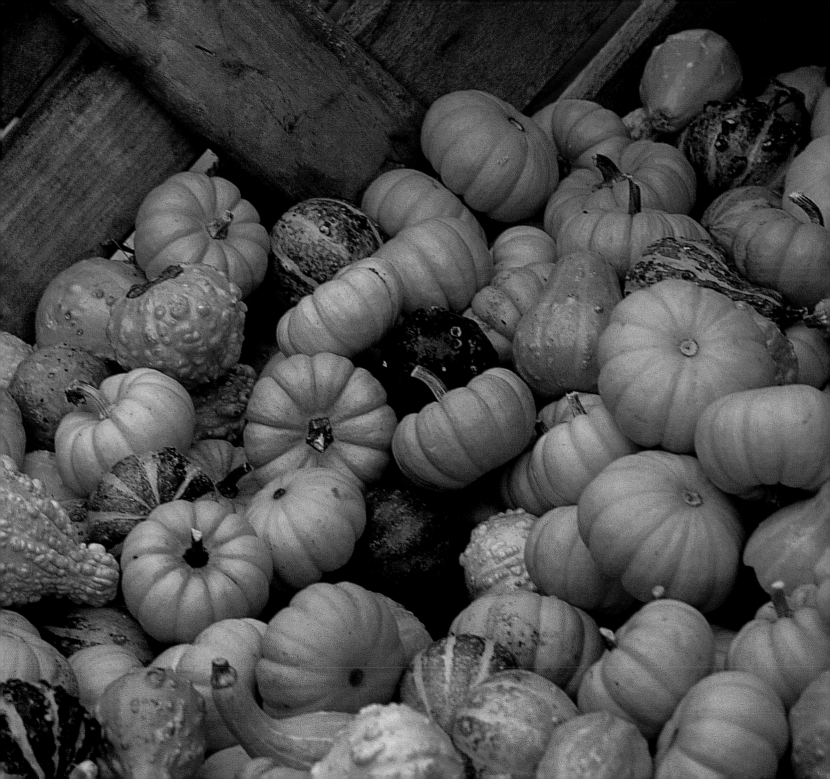

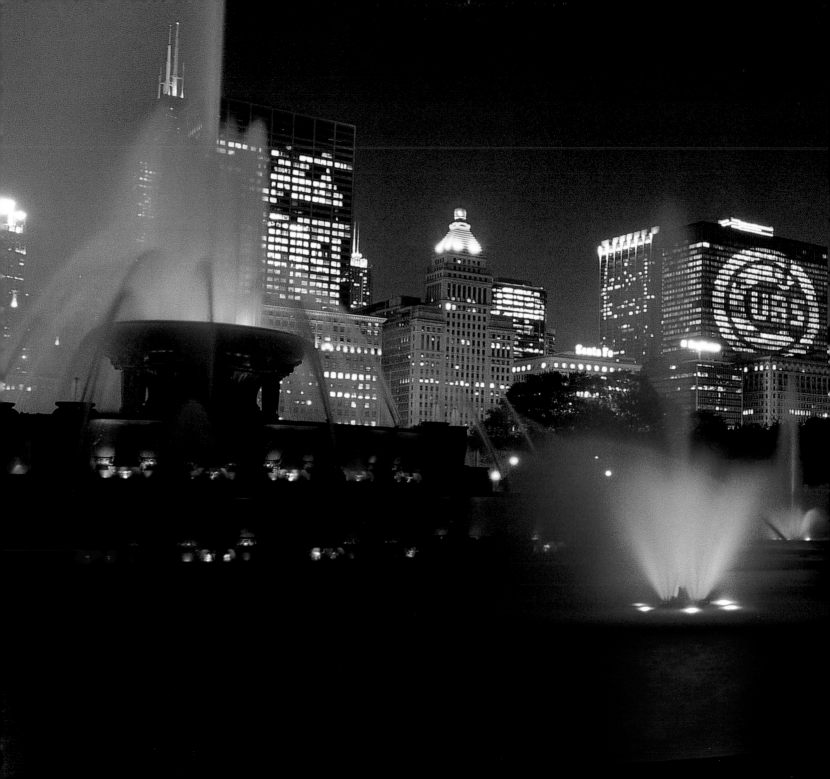

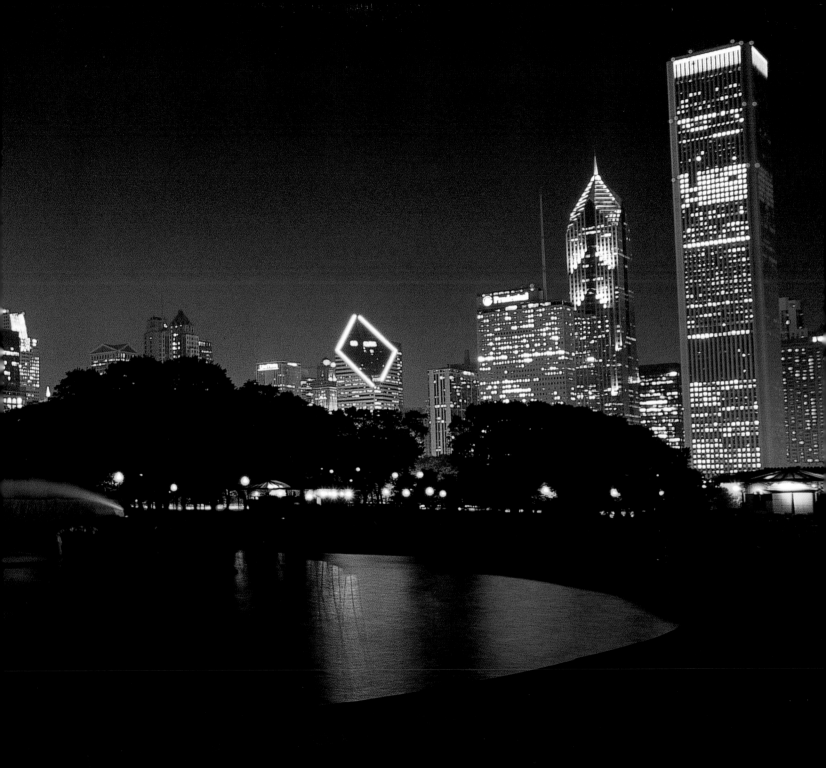

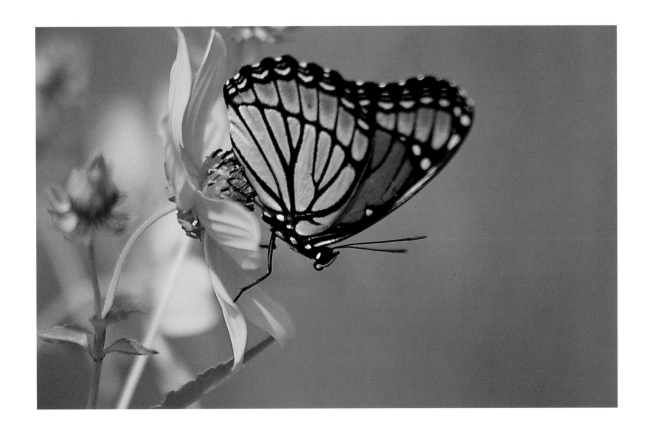

Above: A monarch butterfly pauses on its way south.

Facing page: Water glides over rock: Starved Rock State Park, La Salle County.

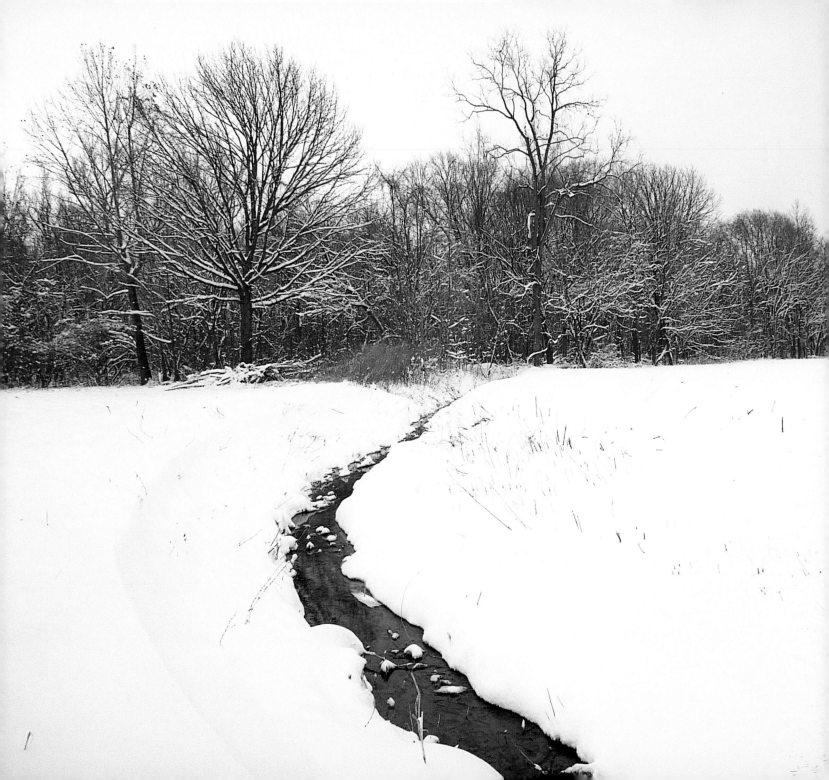

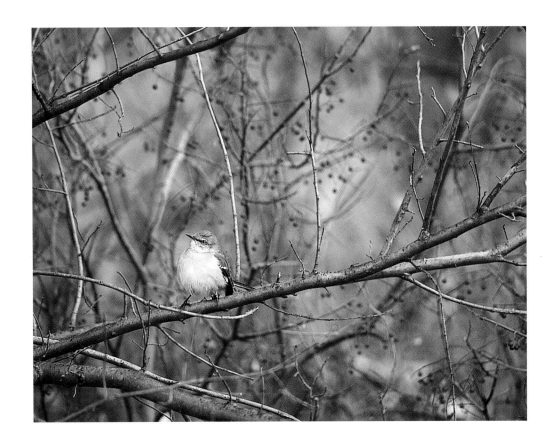

Above: A mockingbird considers winter in Godfrey.

Left: One Monroe County stream holds off the freeze.

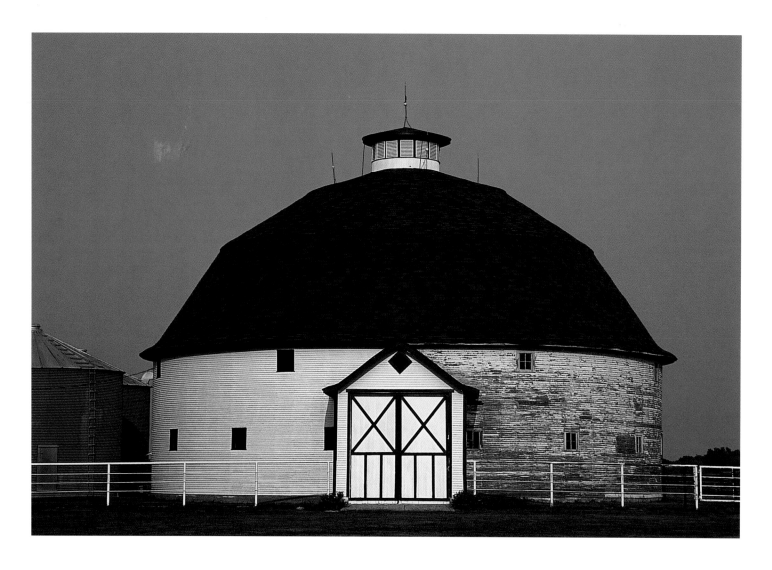

Above: The round barn that ran out of paint, Coles County.

Facing page: Fall leaf captured by prairie grass.

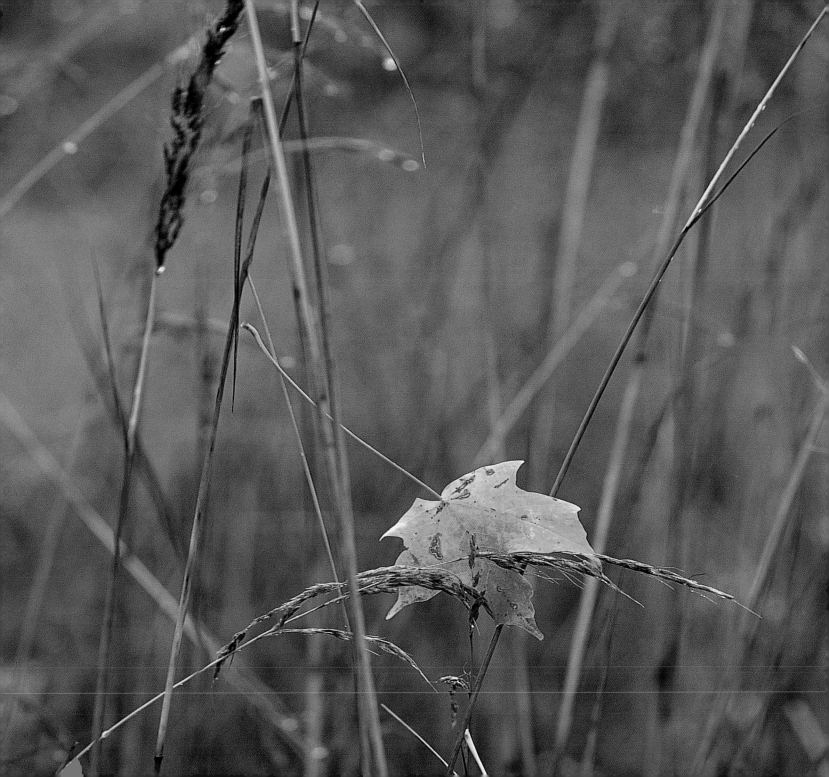

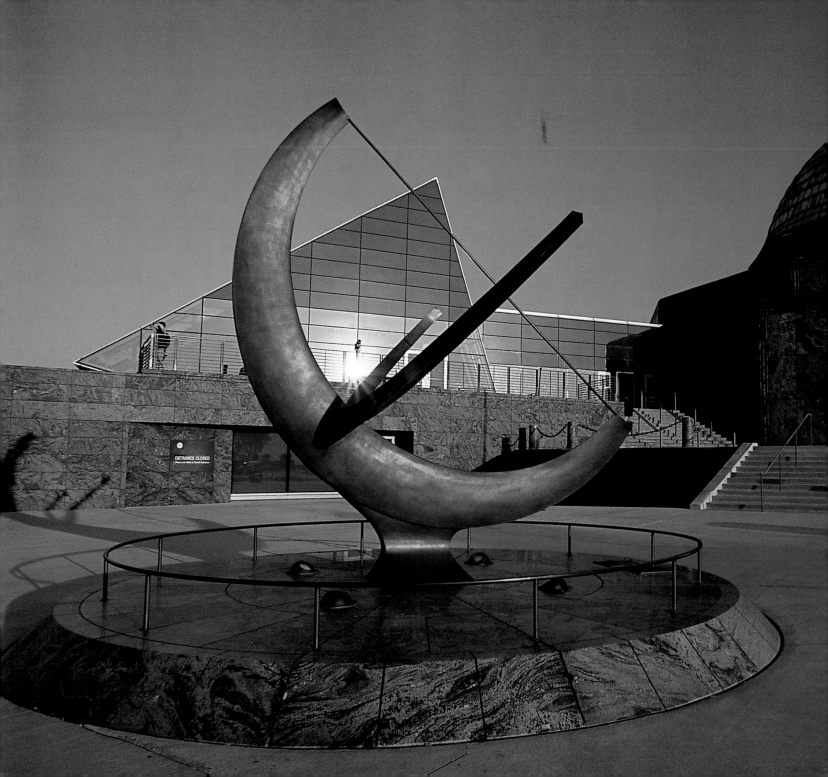

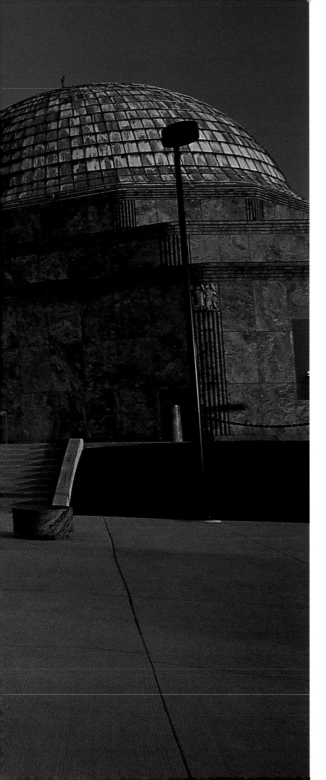

Left: Chicago's Adler Planetarium and Astronomy Museum, founded in 1930 and known as the first planetarium in the Western Hemisphere.

Below: Apartment building as seen through a sculpture in Gateway Park.

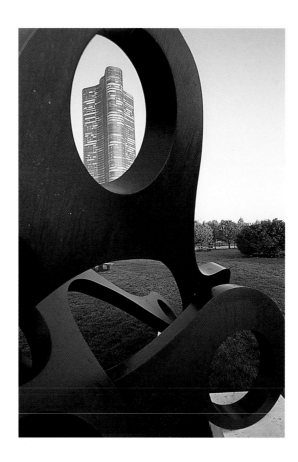

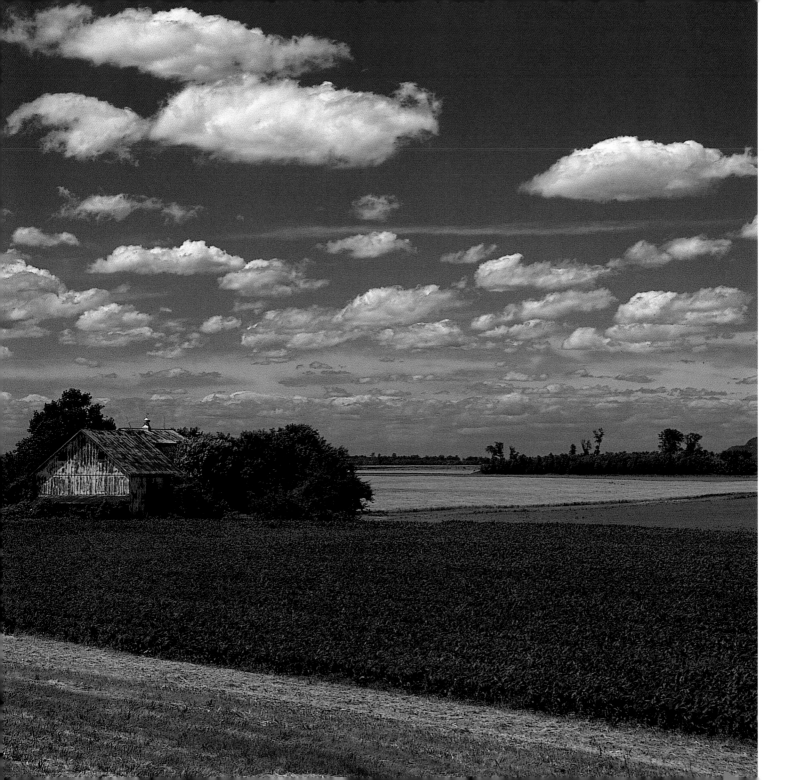

Facing page: Monroe County farmland under an endless parade of clouds.

Below: Color coordination at work.

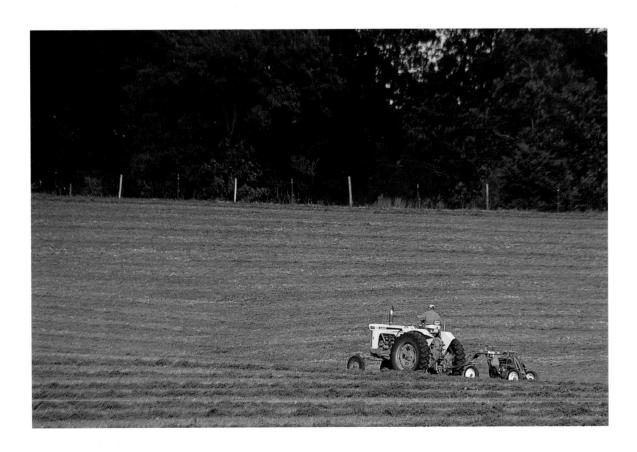

Right: Truck waits in the fading barn, Columbia.

Below: Navy Pier Park and its 150-foot Ferris wheel.

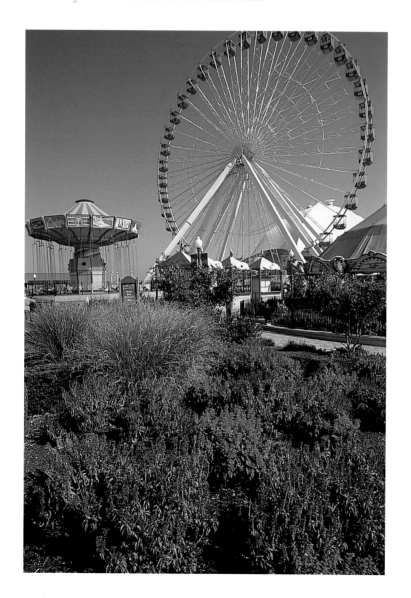

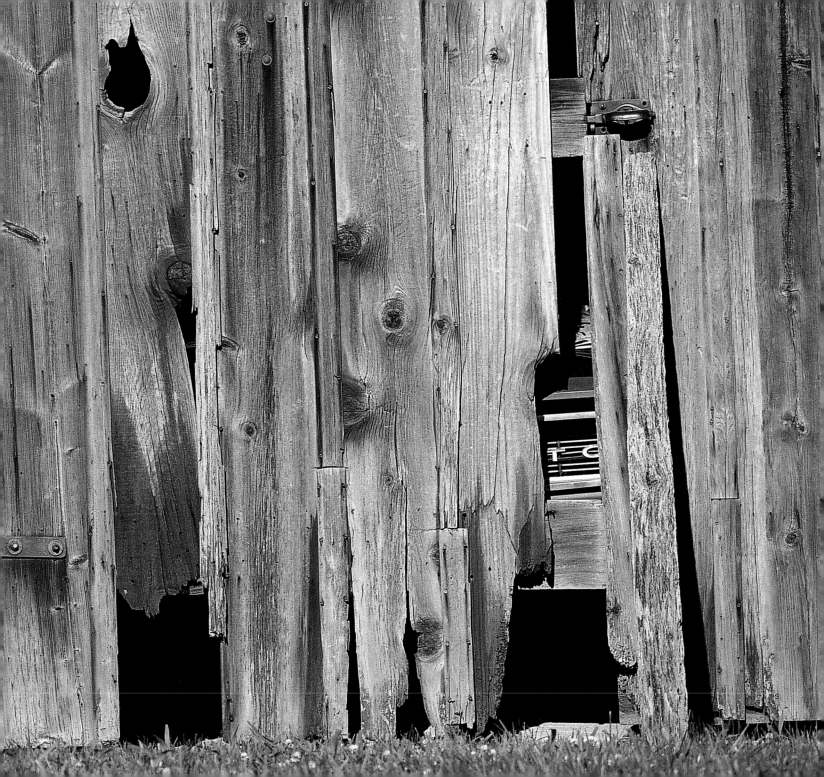

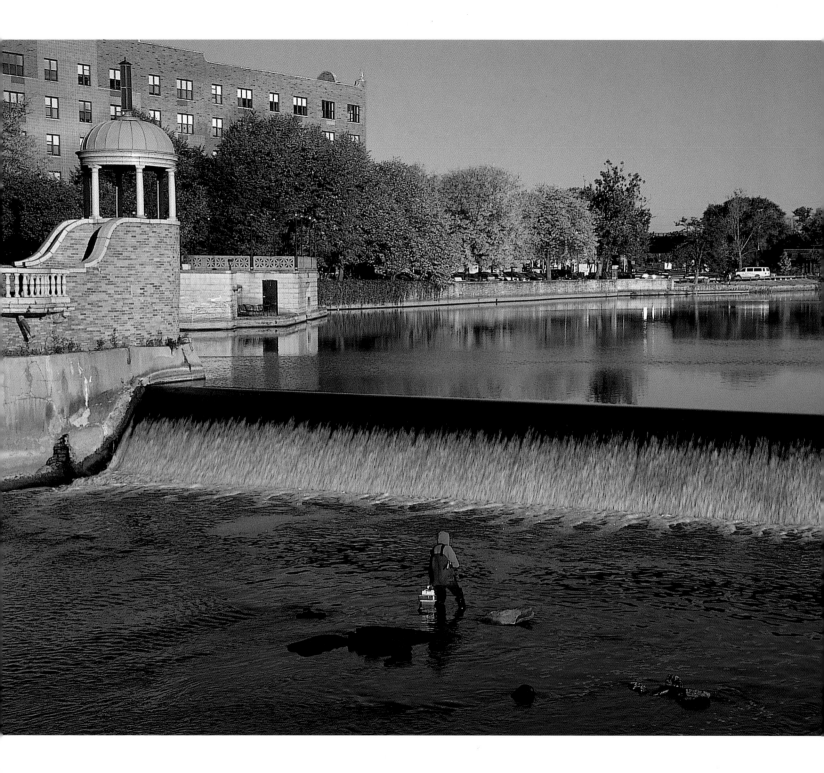

Left: The Fox River flows placidly over a spillway in St. Charles, a fisherman's paradise.

Below: Garden of the Gods, a rock-climber destination in Shawnee National Forest.

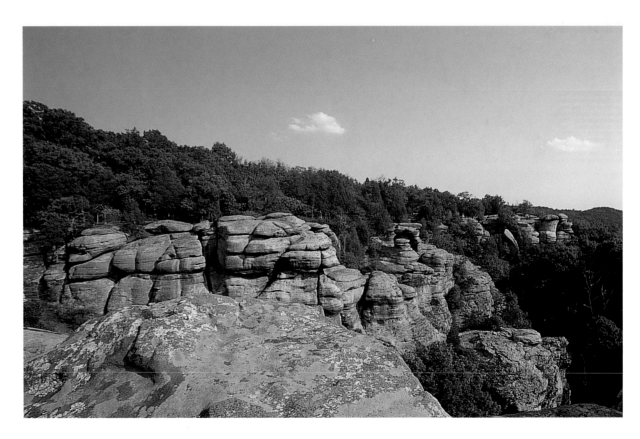

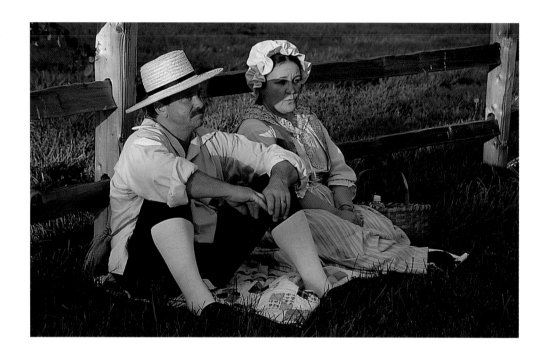

Above: Historic reenactment is a regular event at Fort de Chartres, Randolph County.

Right: On the grounds of Fort de Chartres, a relic of the eighteenth-century French on the Mississippi.

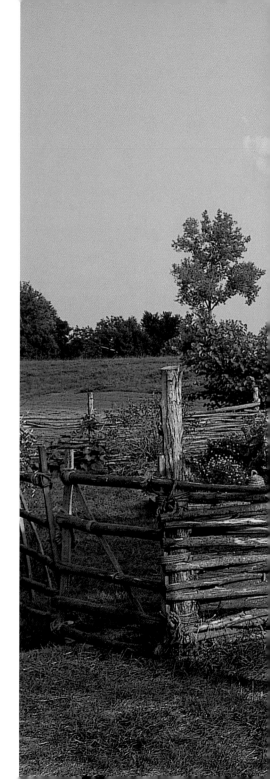

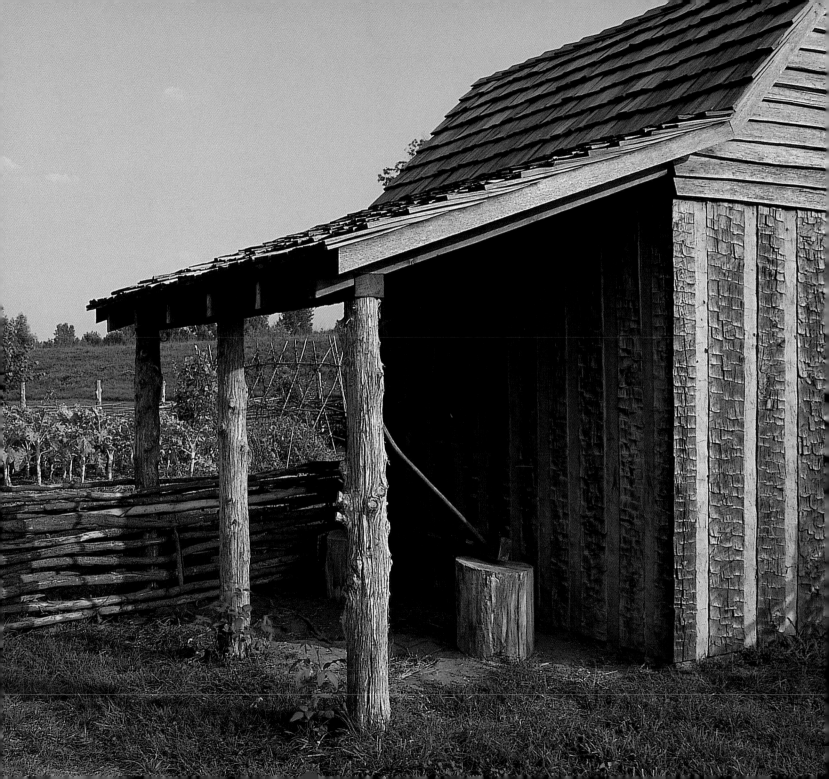

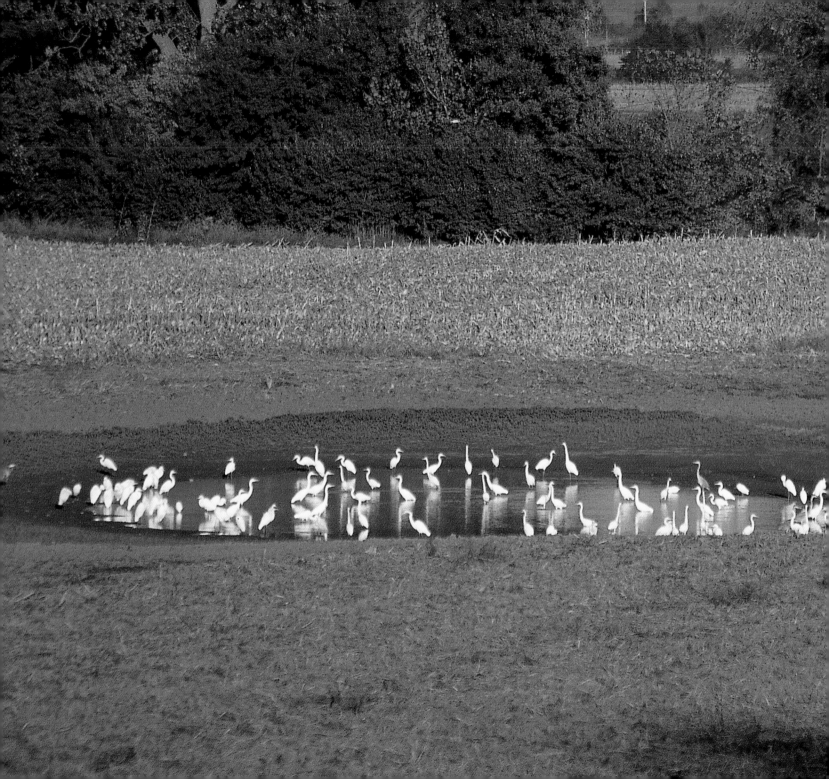

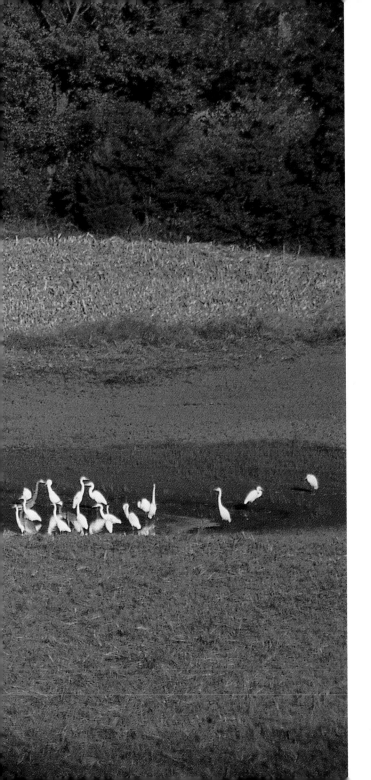

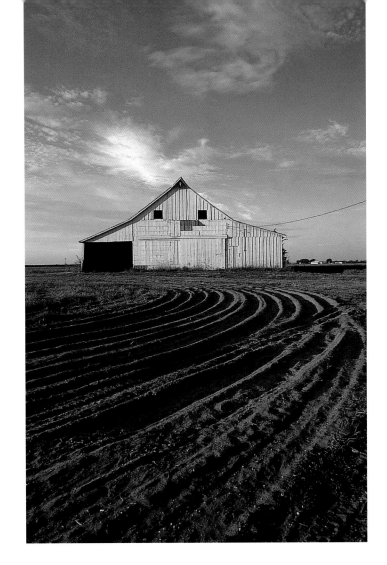

Above: Geometries of farmwork, Monroe County.

Left: Egrets converge on a large field puddle created by the recent rain.

Facing page: Capitol building in Vandalia, the first capital of Illinois, 1819–1839.

Below: Bikers on Levee Road, Monroe County.

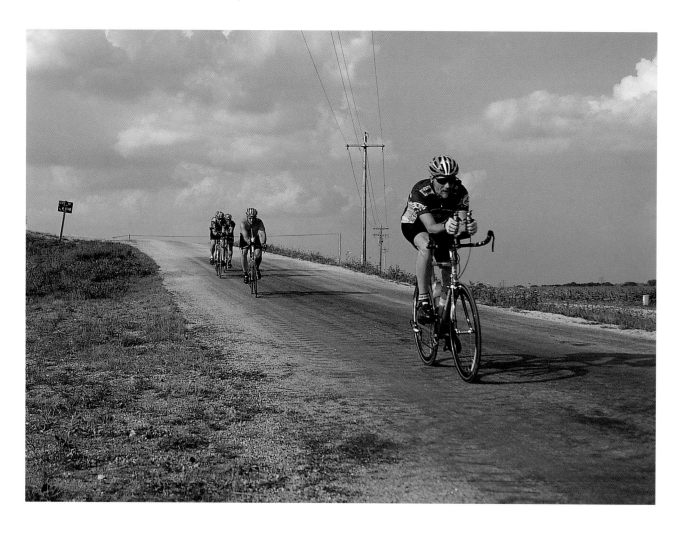

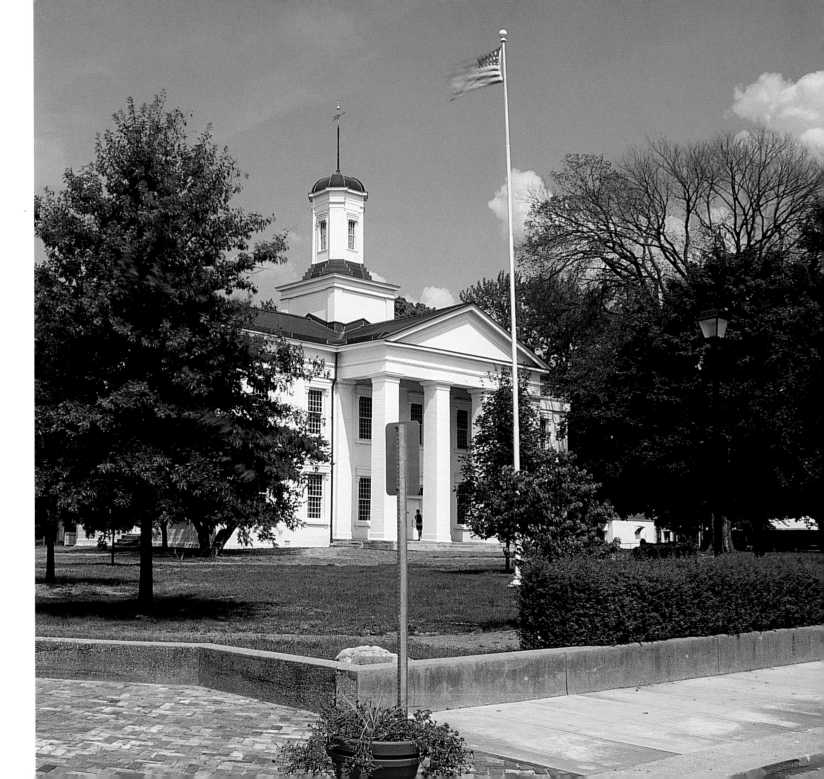

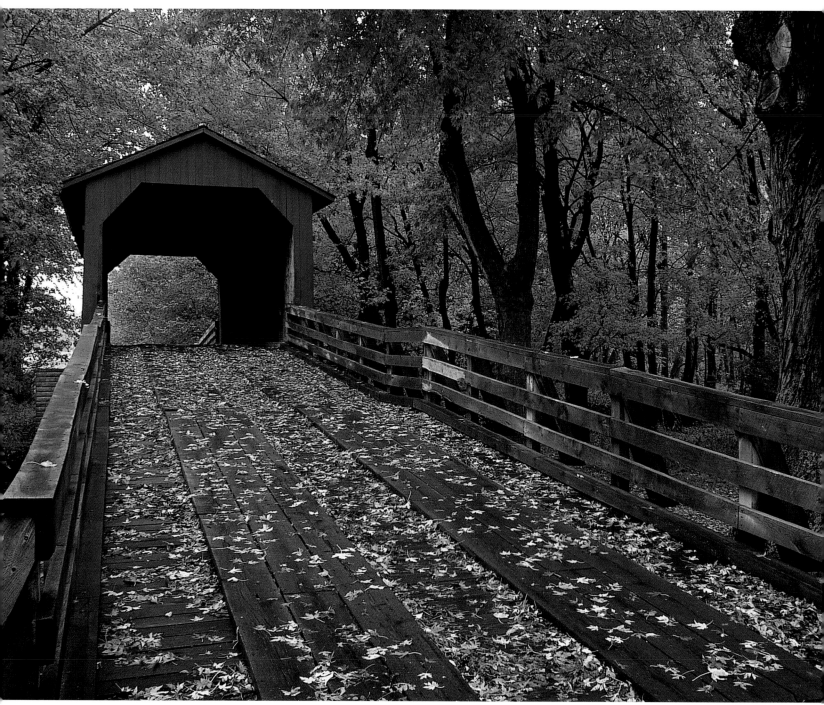

Facing page: A covered bridge over Sugar Creek, Sangamon County, collects autumn's leaves.

Below: Geese at Horseshoe Lake obey the speed limit, but will they look both ways before crossing?

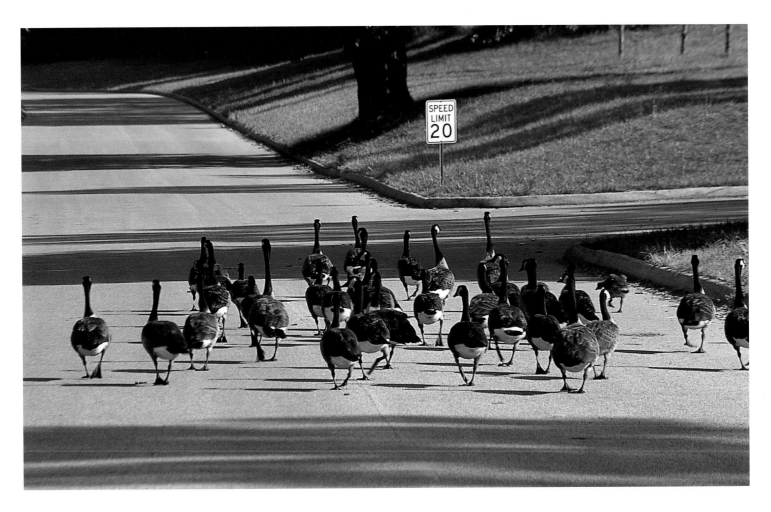

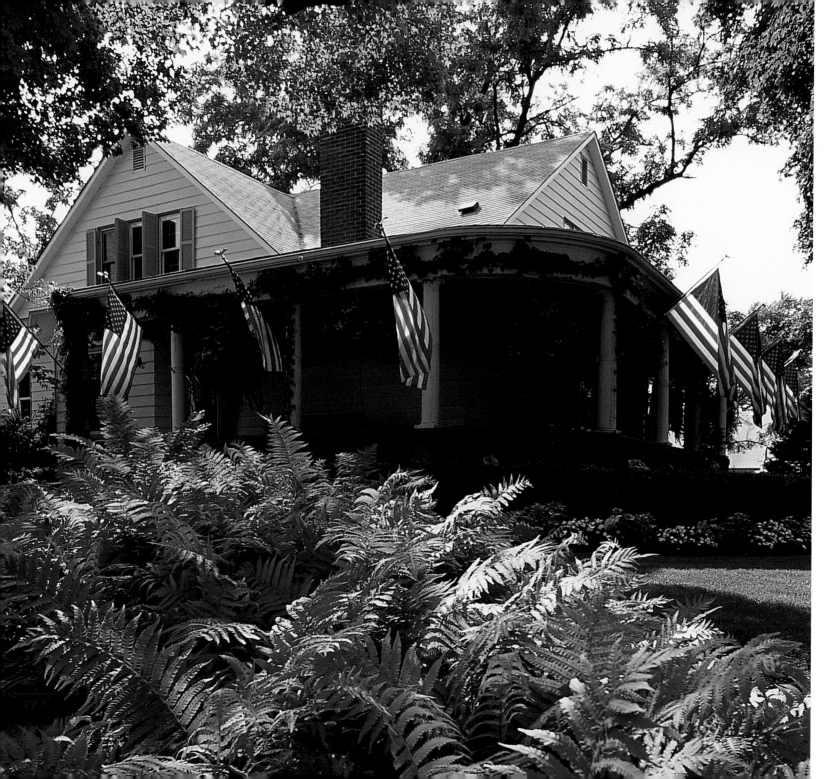

Facing page: Flags and ferns each wave their colors at this Columbia home.

Below: A northern cardinal shows his colors from a juniper perch.
PHOTO BY RICHARD DAY.

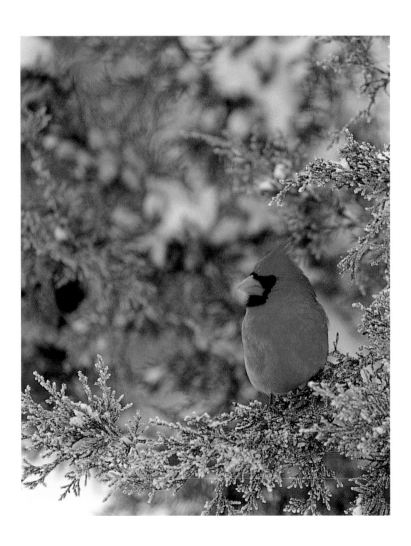

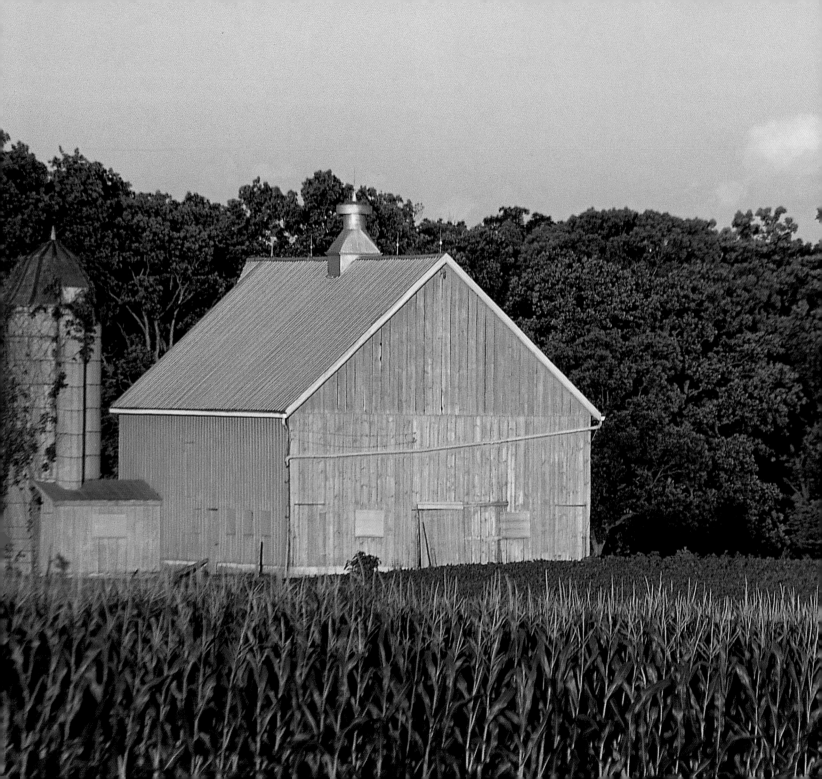

Left: Waterloo barn glows with the setting afternoon sun.

Below: Rockford farmer takes a break. PHOTO BY SUSAN MORAN.

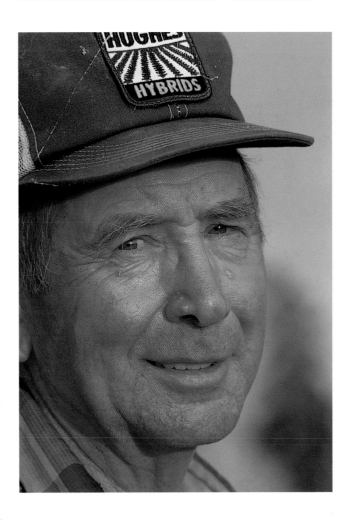

Right: Covered bridge, Cumberland County.

Below: Abe Lincoln worked here: the old state capitol building in Springfield.

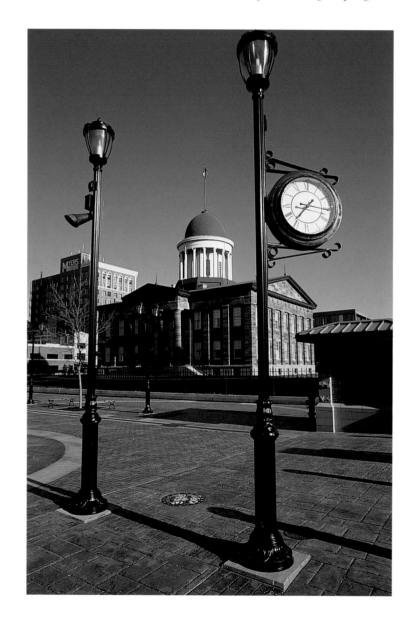

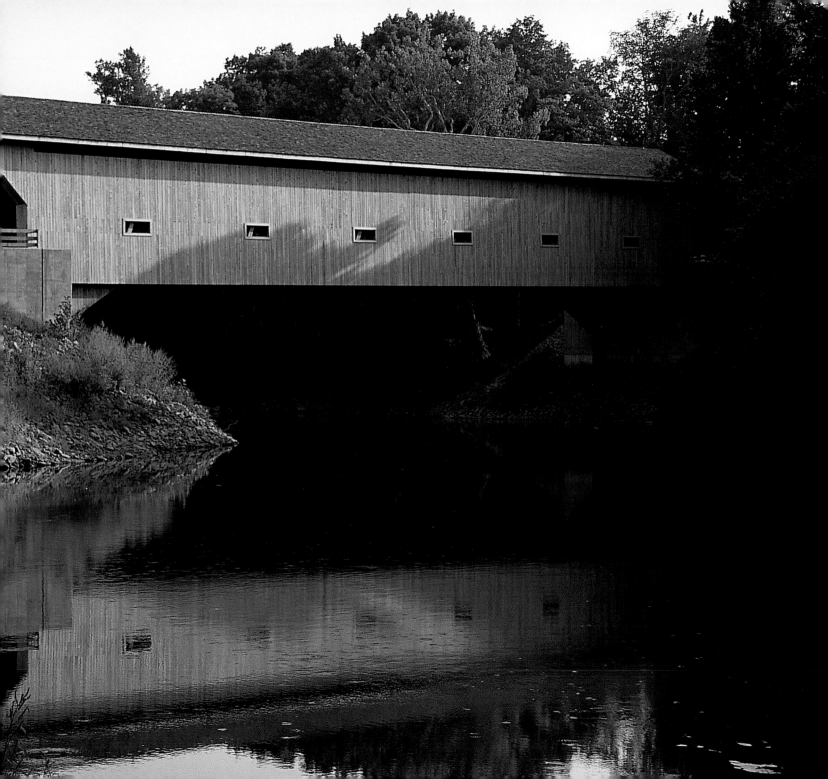

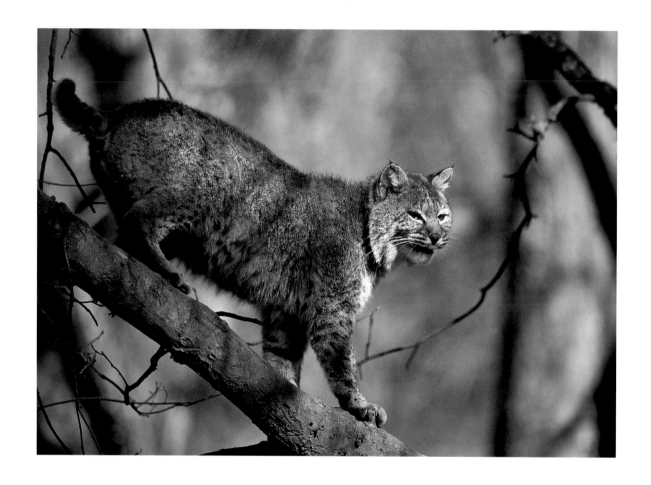

Above: Bobcats, once wild in the region, now find a home at Wildlife Prairie Park, in Peoria.

Facing page: New reflects old in downtown Springfield.

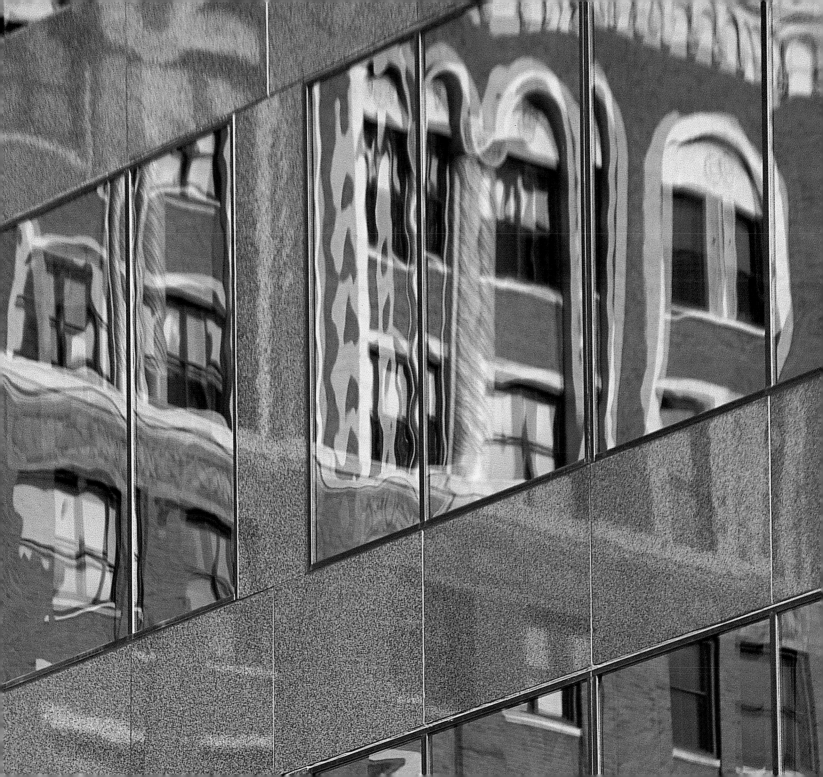

Right: The Rose Hotel, in Elizabethtown on the Ohio River, first hosted guests in 1812.

Below: Swallowtail on coneflower.

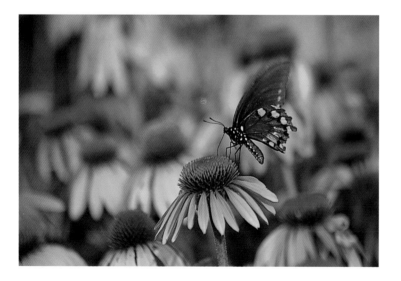

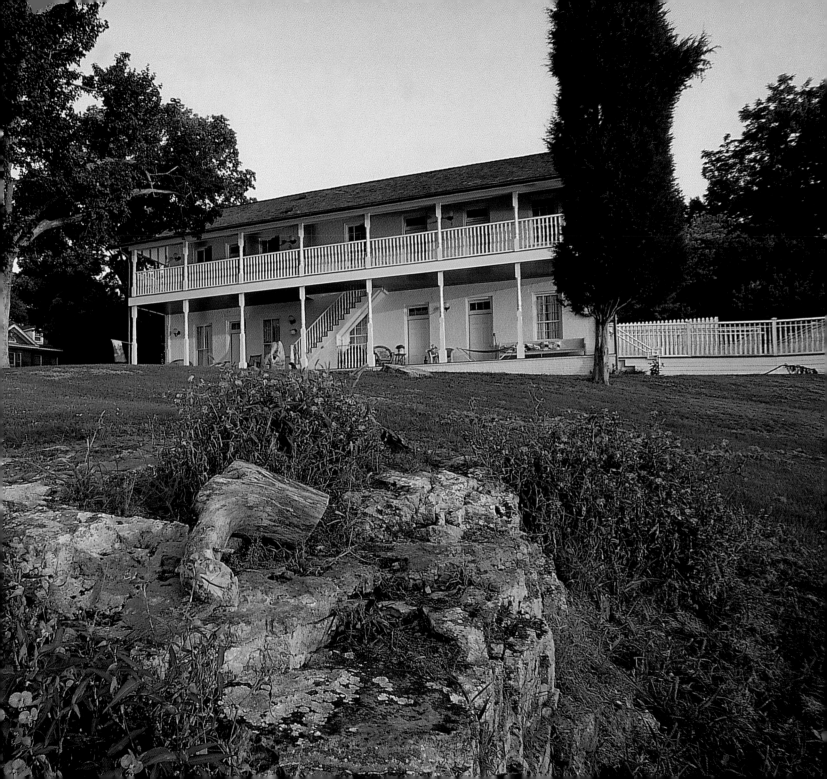

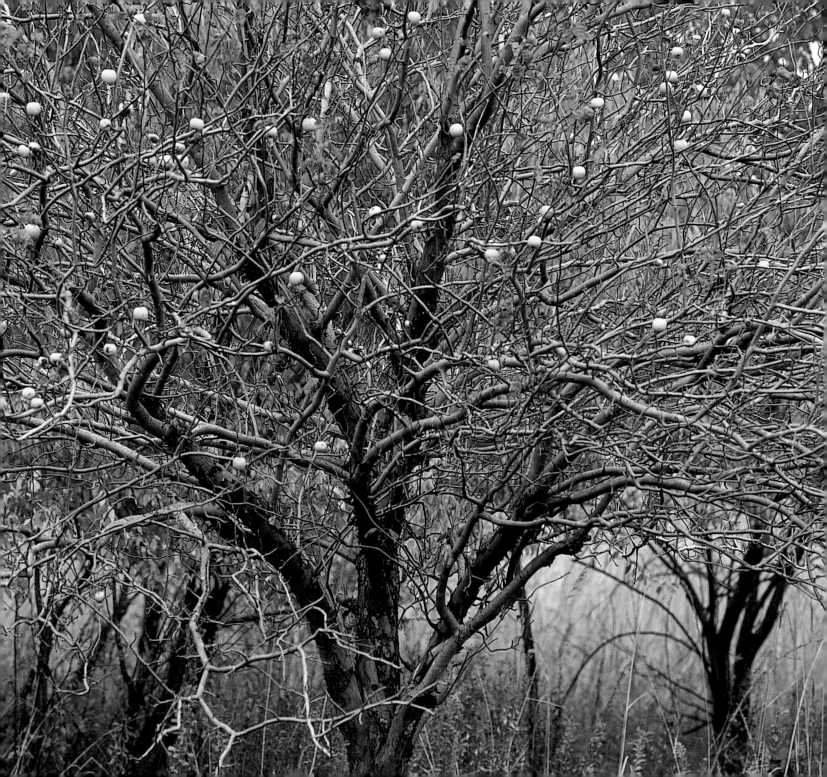

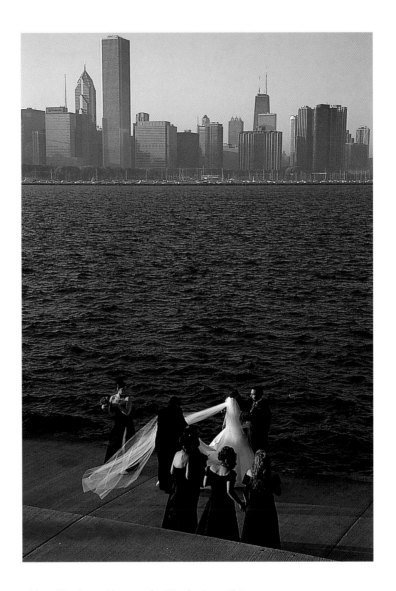

Above: Windy wedding in the Windy City, Chicago.

Left: Trees hold on to their fruit after the leaves have fallen, near Goose Lake Prairie State Natural Area.

Facing page: The Murray Baker Bridge carries Interstate 74 over the Illinois River into Peoria.

Below: Wrigley Field celebrates its ninety-first season in 2004. PHOTO BY SUSAN MORAN.

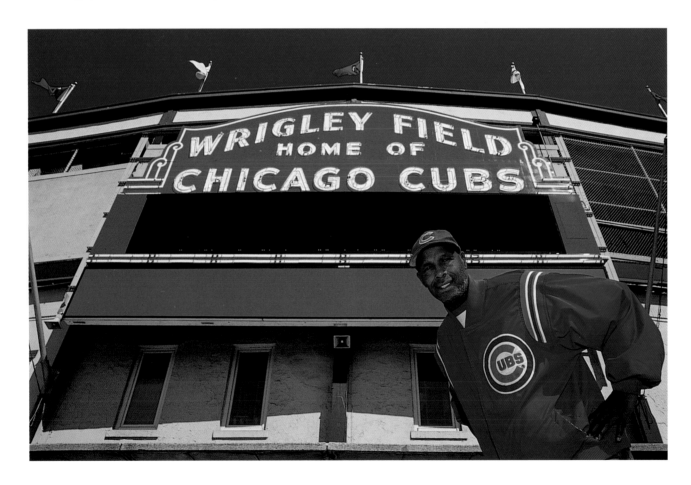

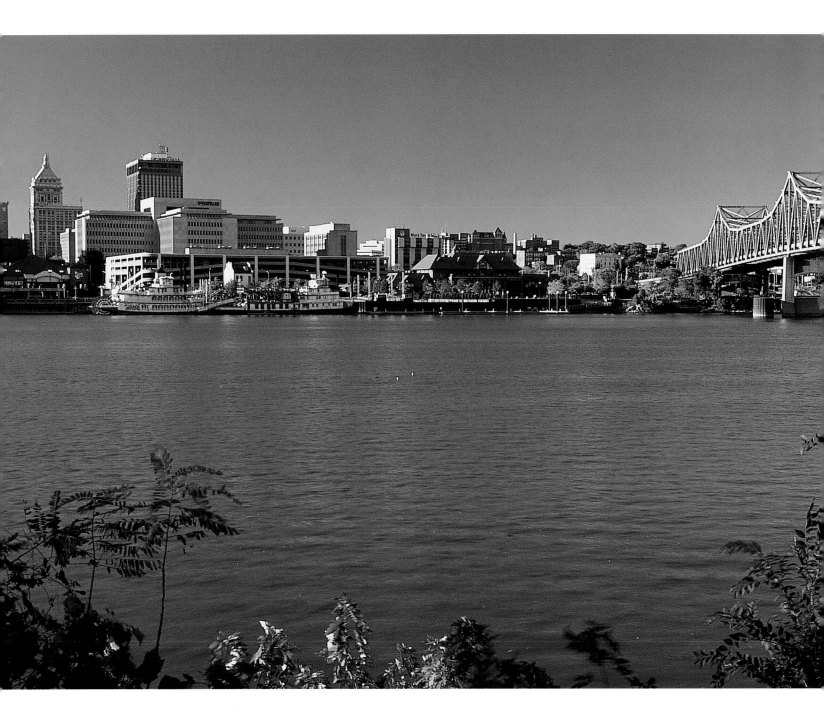

Left: Waiting for harvest, Madison County.

Below: Shawneetown Bank, Greek Revival architecture from the 1840s.

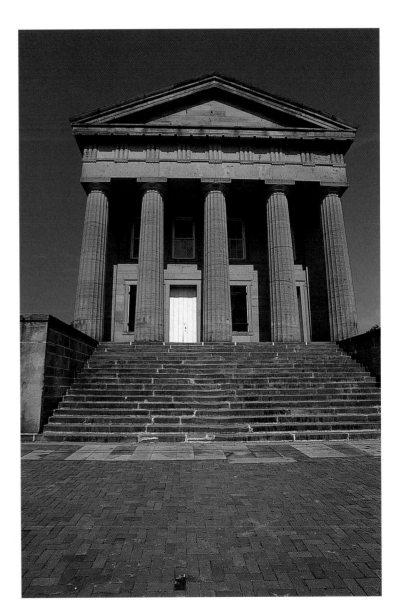

Facing page: West-central farmland bright in the still afternoon.

Below: First the hat, then the body fly at the Grafton rodeo.

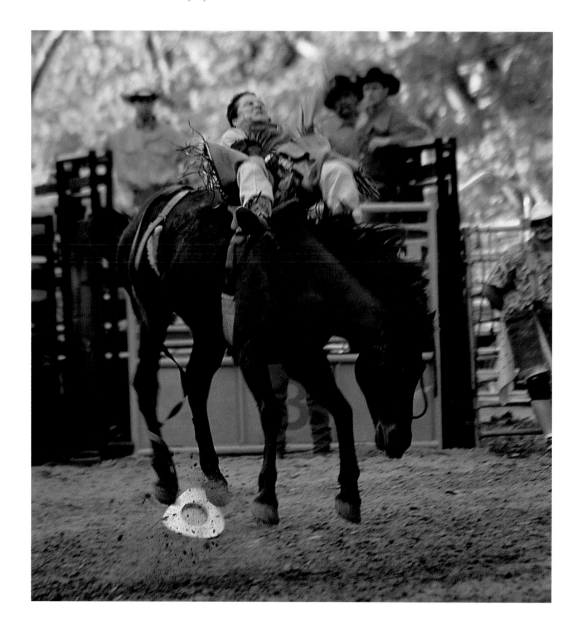

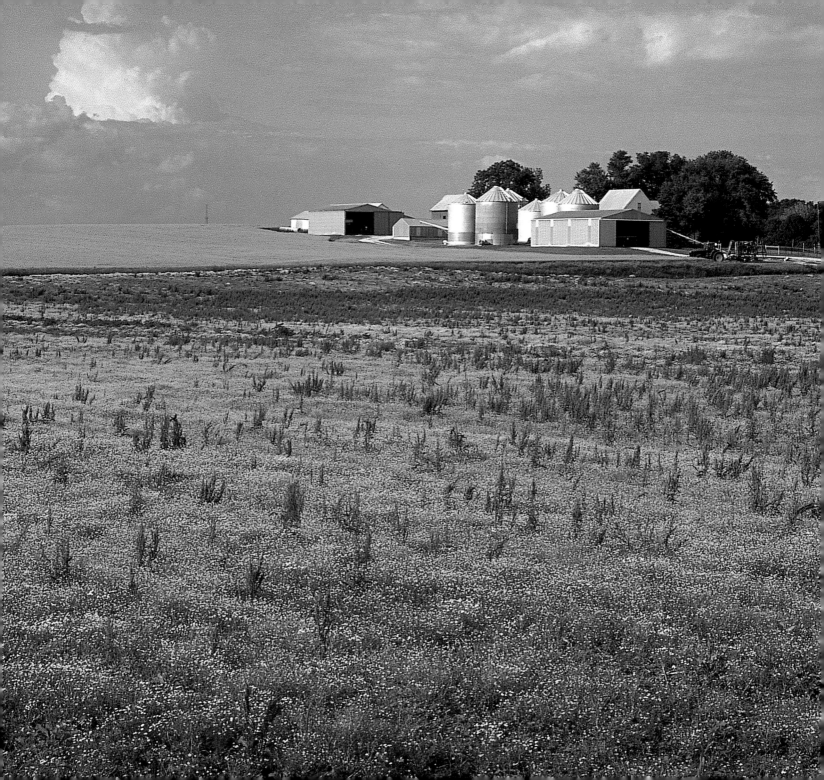

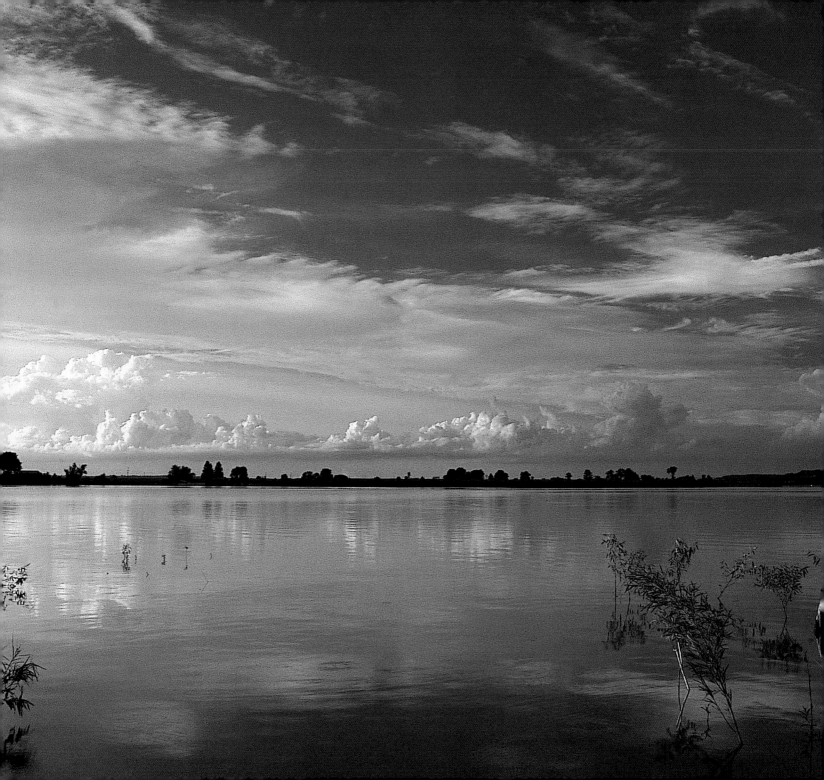

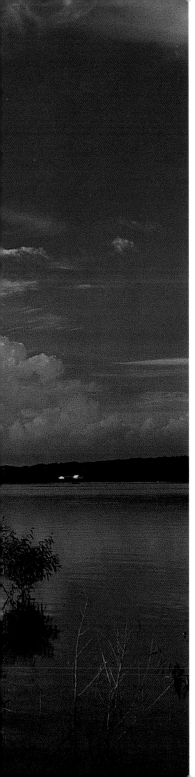

Left: Lake Moredock: high water in the Mississippi River Valley.

Below: North Michigan Avenue, Chicago.

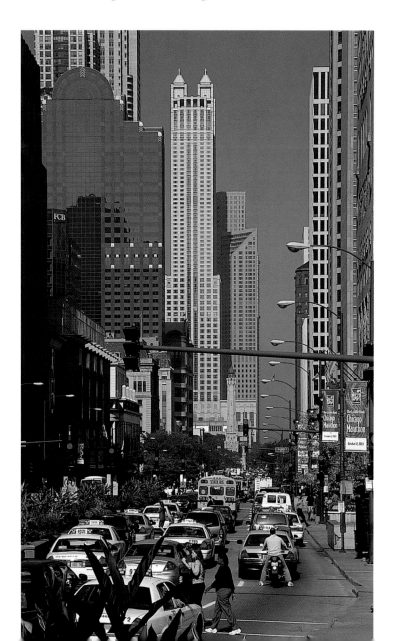

Right and Below: The Mississippi riverboat *Spirit of America* houses the Alton Belle Casino.

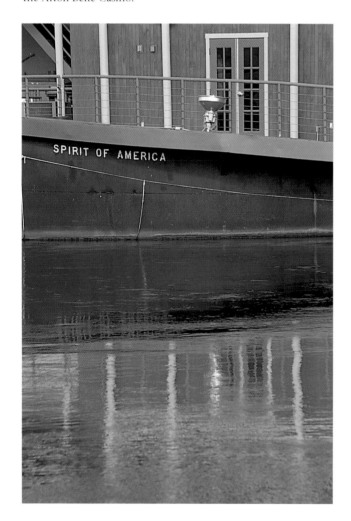

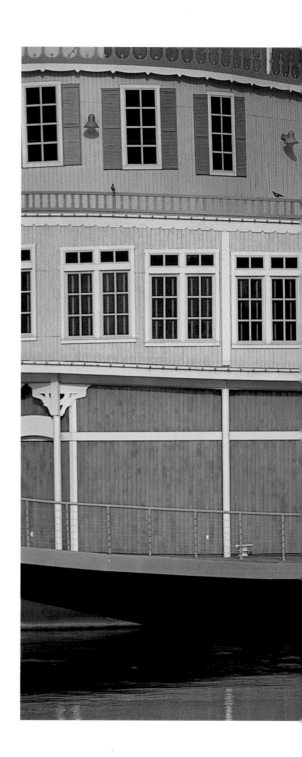

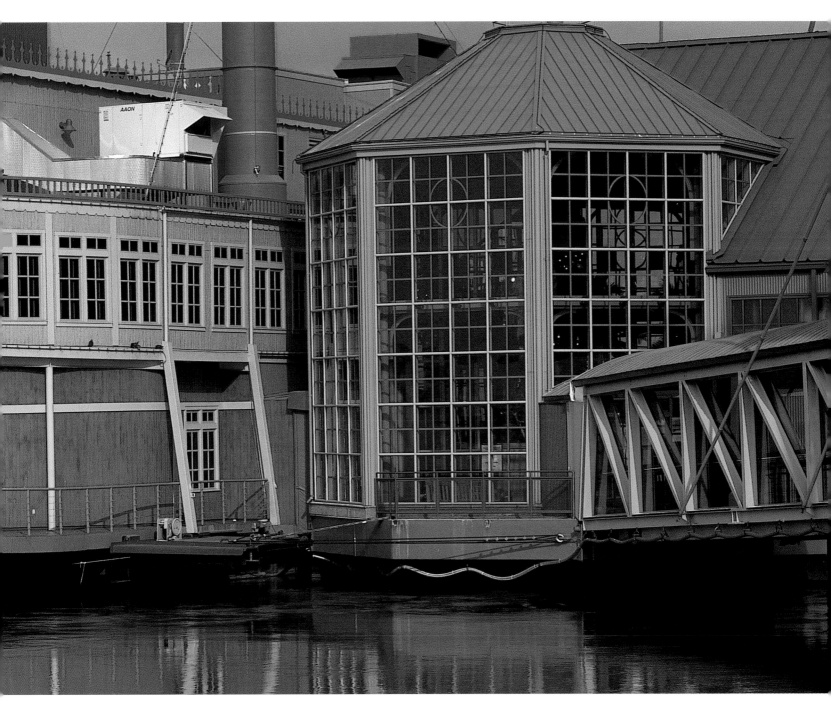

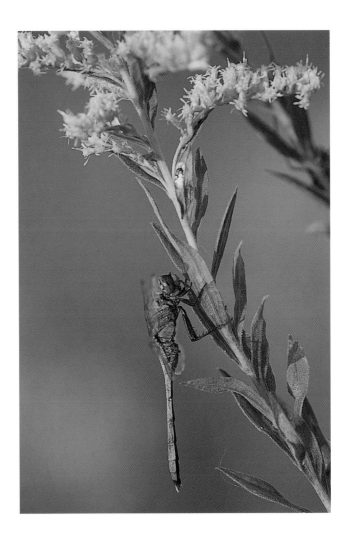

Above: Dragonfly, Gordon Moore Park in Alton.

Left: An inn awaits its late-arriving lodgers in historic Elsah.

Facing page: Pigs snacking in the fading daylight.

Below: Etched sandstone, Garden of the Gods, Shawnee National Forest.

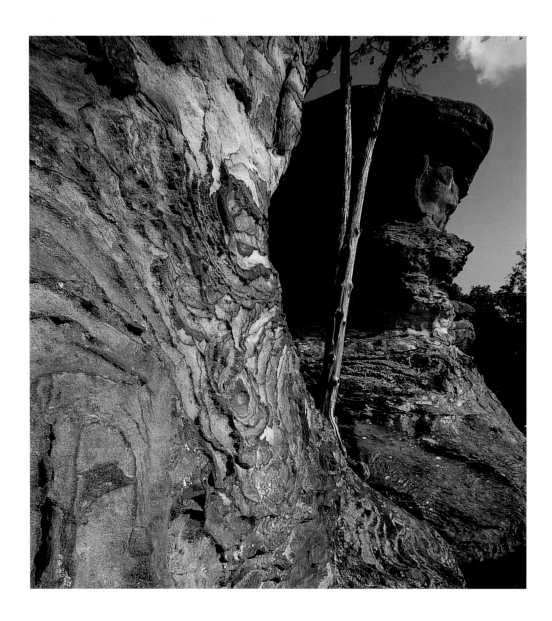

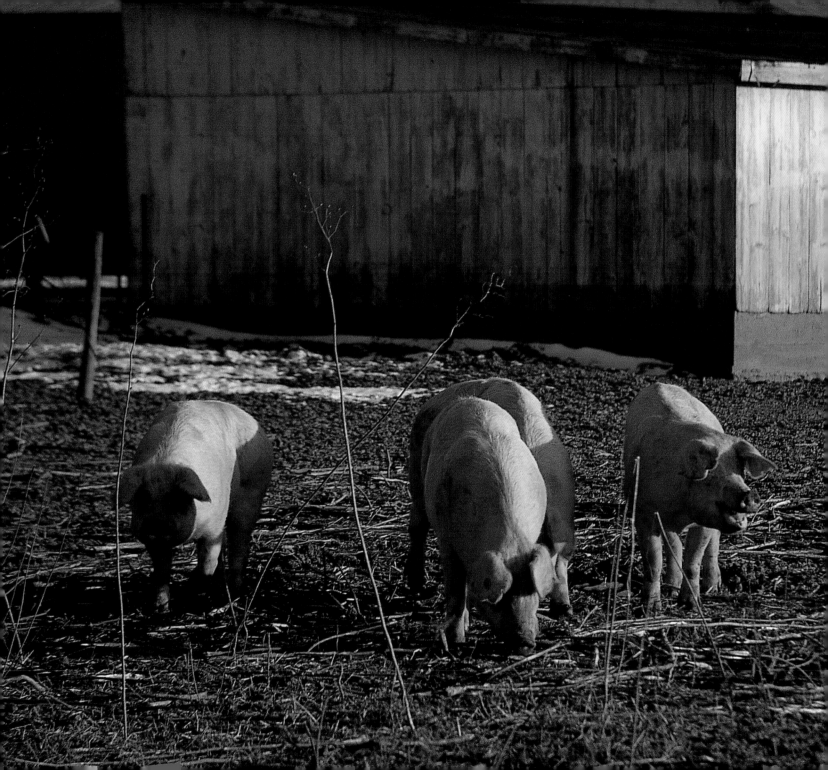

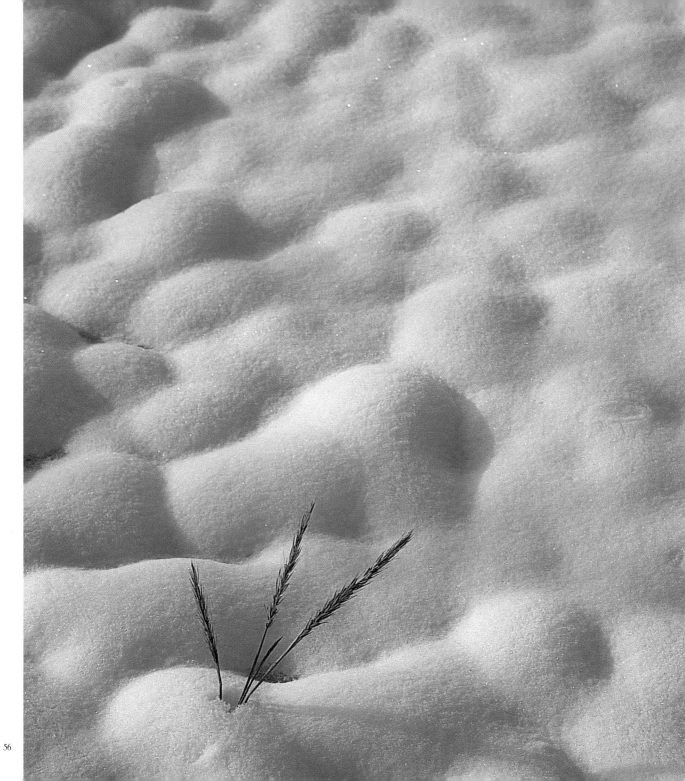

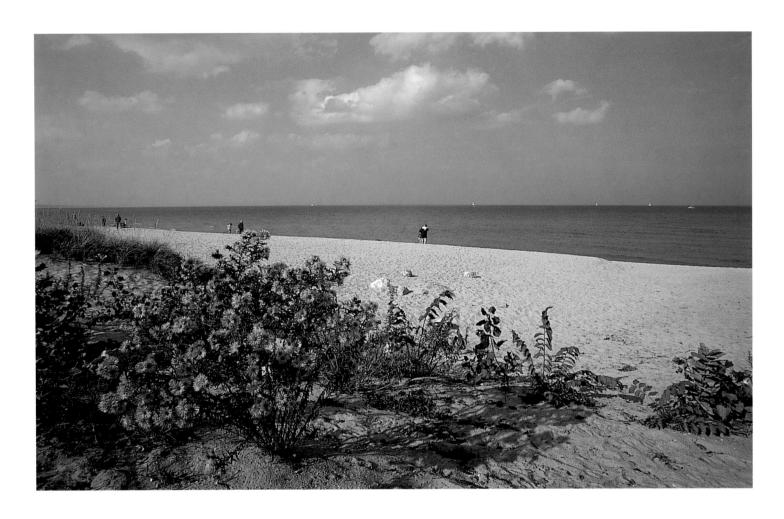

Above: Lake Michigan and the popular dunes of Illinios Beach State Park, at the far northeast tip of the state.

Facing page: Snow mounds cover the stubble of hibernating farmland.

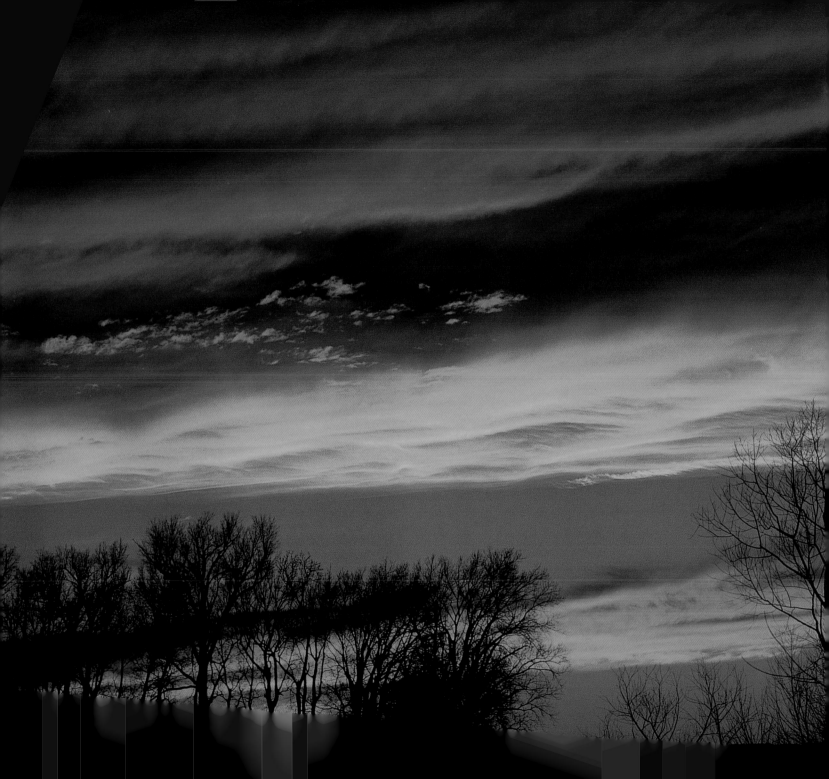

Left: A winter sunset, fire and ice.

Below: One of several museums devoted to the culture of Route 66.

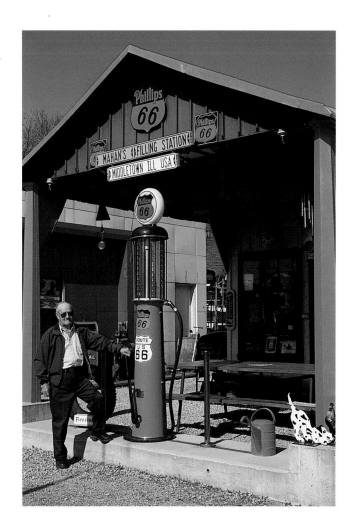

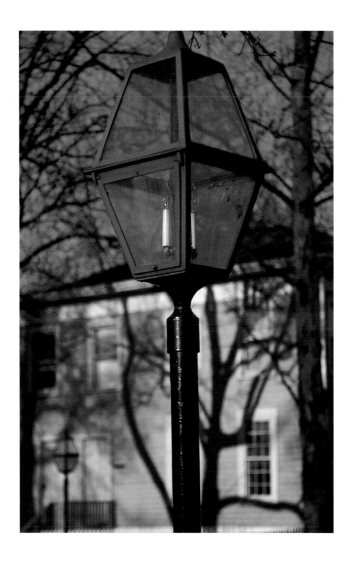

Above: Streetlamp in historic Springfield.

Facing page: Amish barn and buggy, Douglas County.

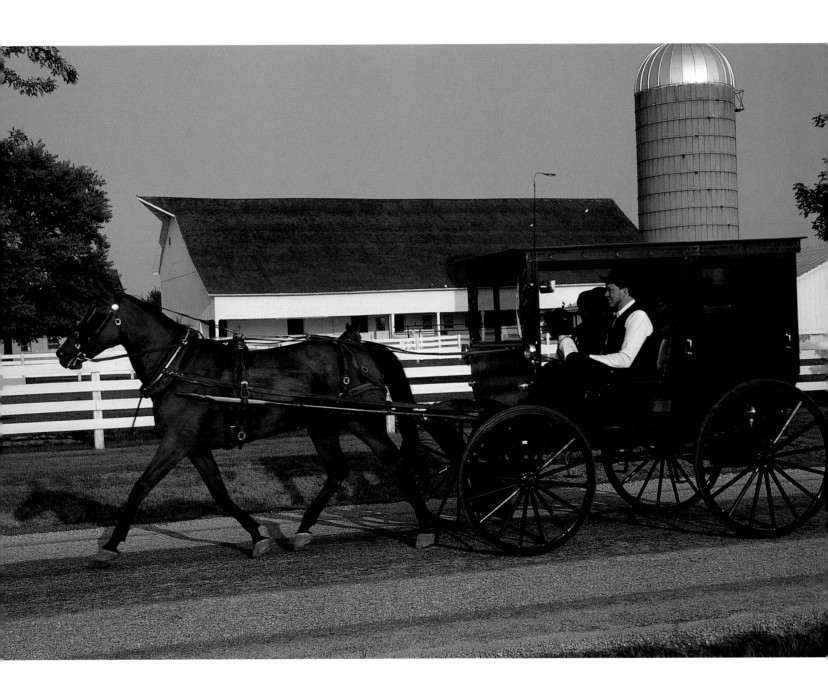

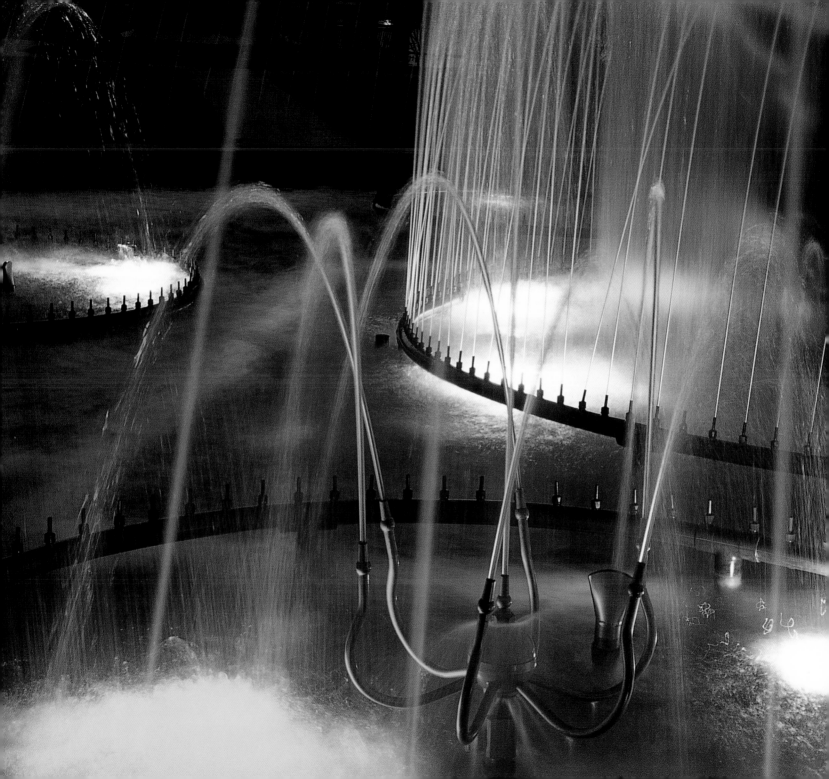

Facing page: Fountain at Edwardsville Public Library.

Below: Pink dogwood in bloom, Red Bud.

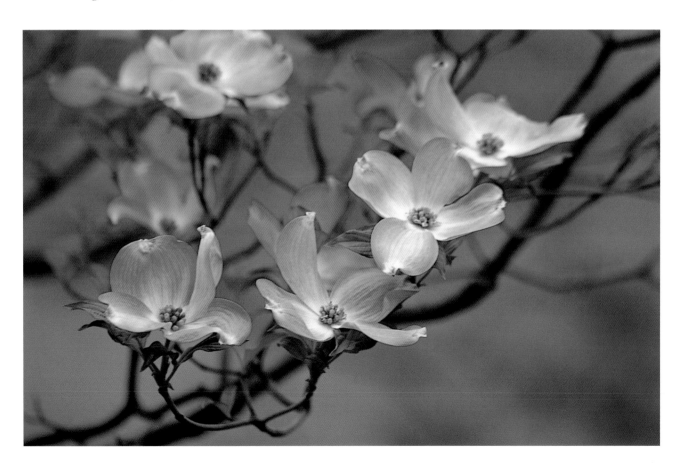

Right: Nauvoo home and pasture of purple.

Below: Friendly embrace, Rockford. PHOTO BY SUSAN MORAN.

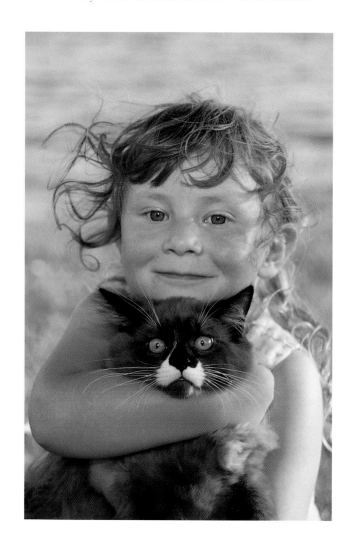

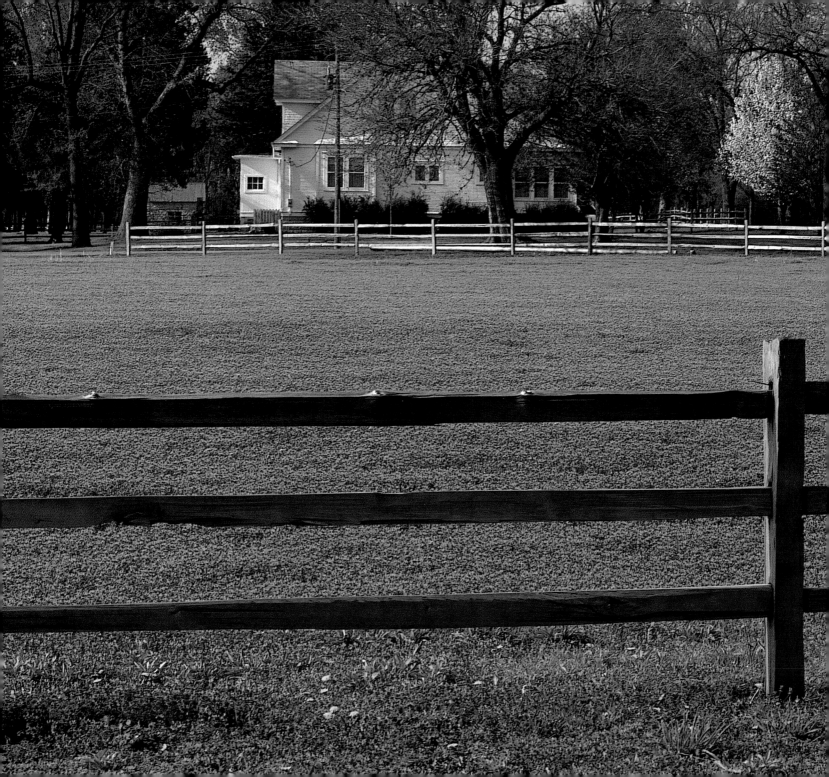

Above: Hanging out in Rockford. PHOTO BY SUSAN MORAN.

Facing page: Sunflowers on a Douglas County farmstead.

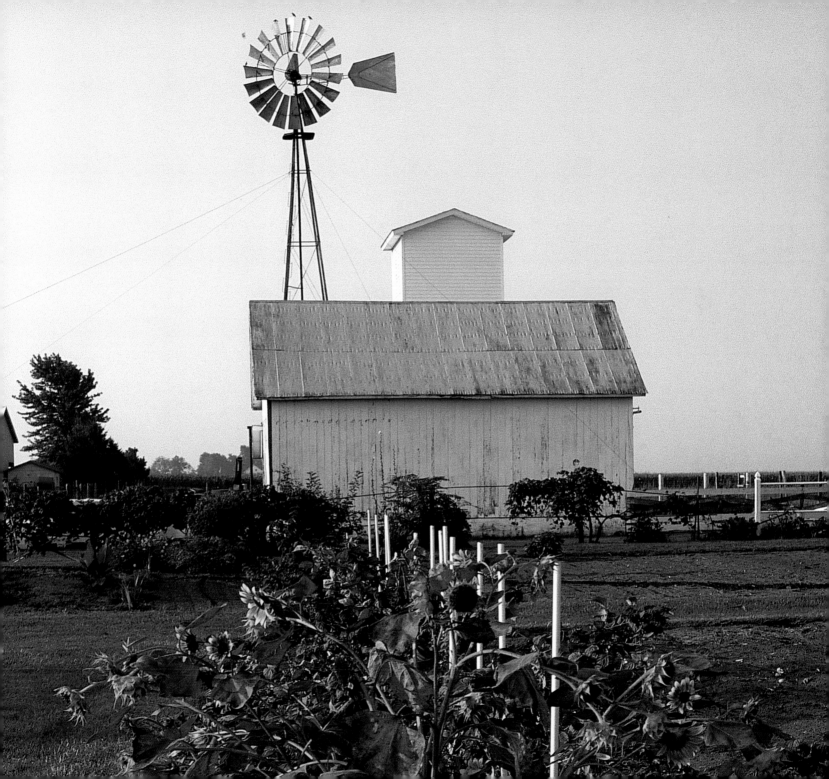

Right: Gazebo on the grounds of the Rose Hotel overlooks the Ohio River.

Below: A lone heron prowls Horseshoe Lake, Madison County.

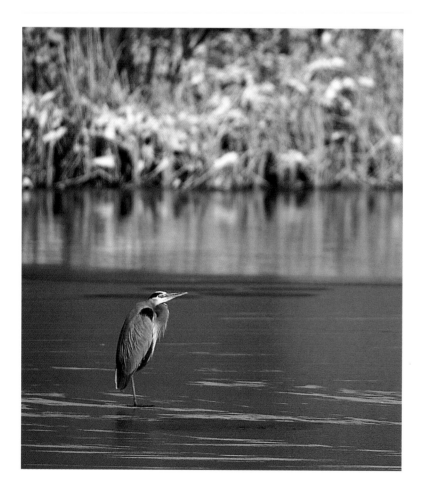

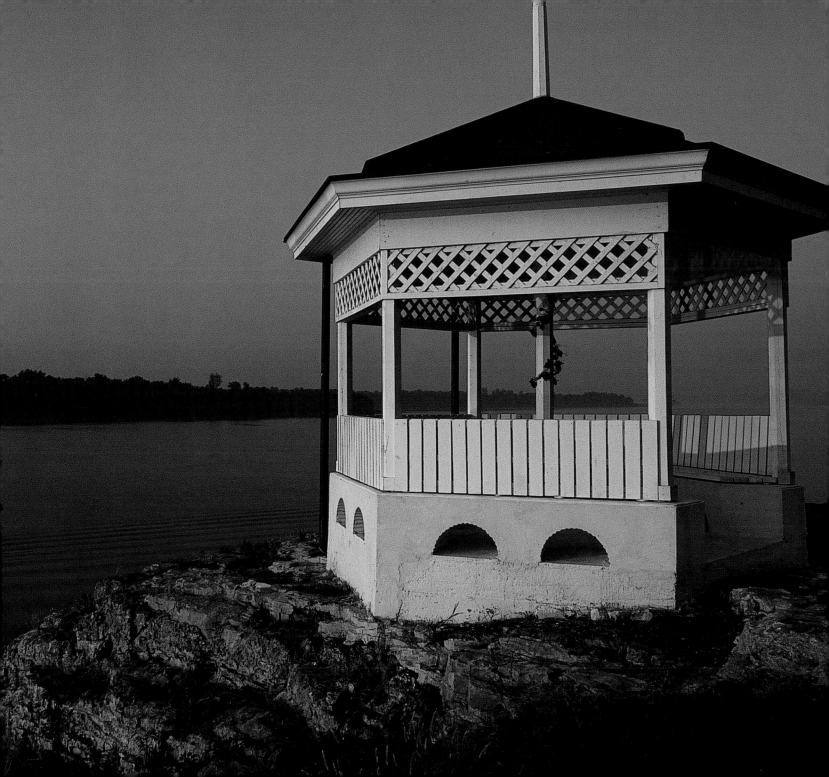

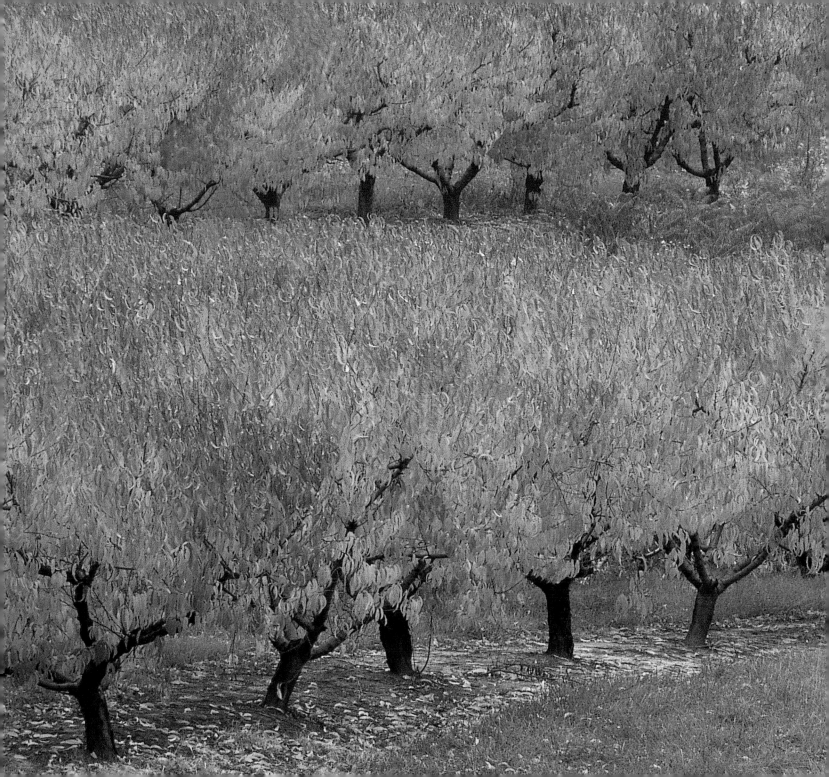

Left: Peach orchard displays fall foliage.

Below: A bountiful harvest. PHOTO BY SUSAN MORAN.

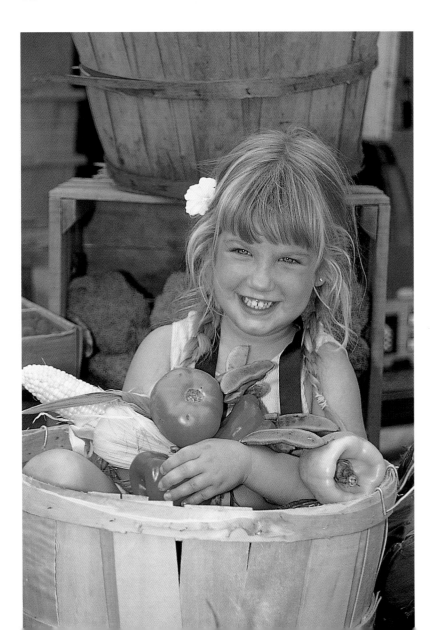

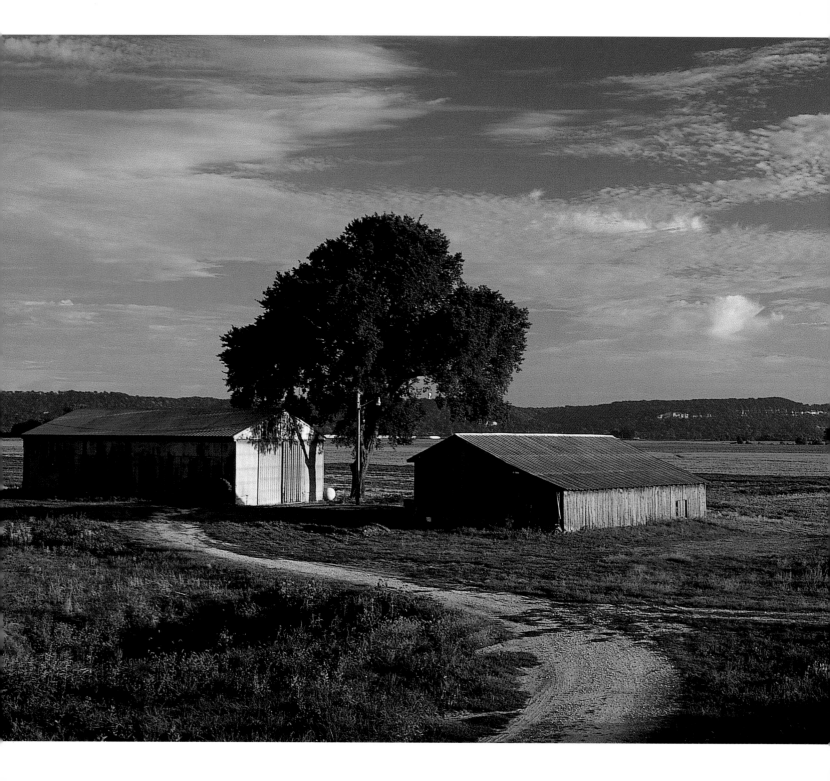

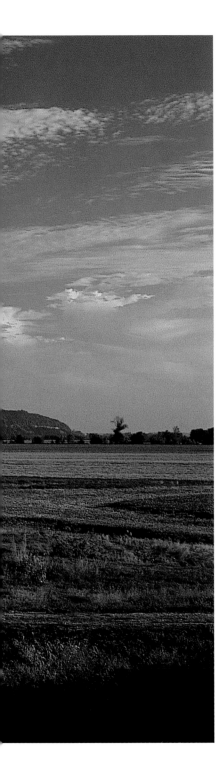

Left: The Misissippi rolls by just behind those bluffs, in Monroe County.

Below: Horses out for a graze, Douglas County.

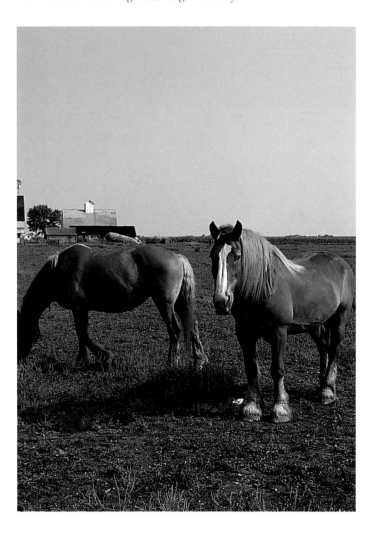

Facing page: Stone bridge, Quincy.

Below: Grain elevators await the harvest.

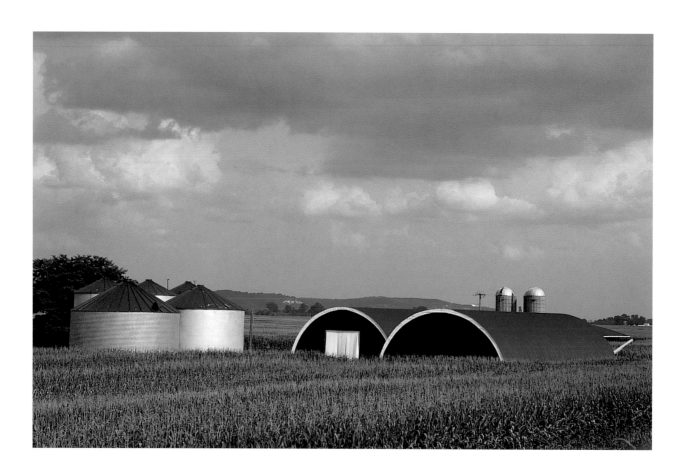

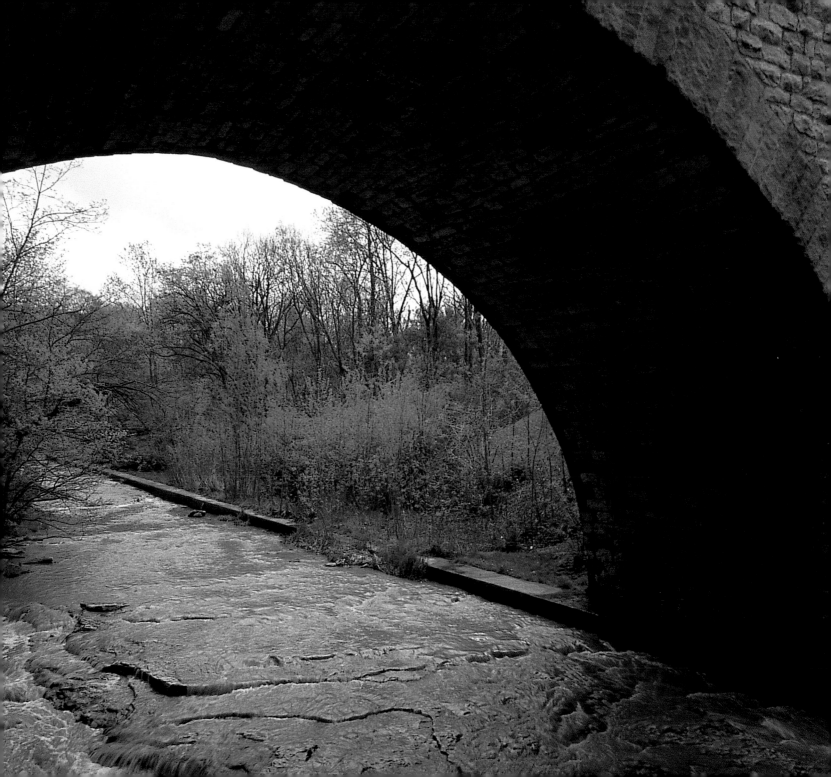

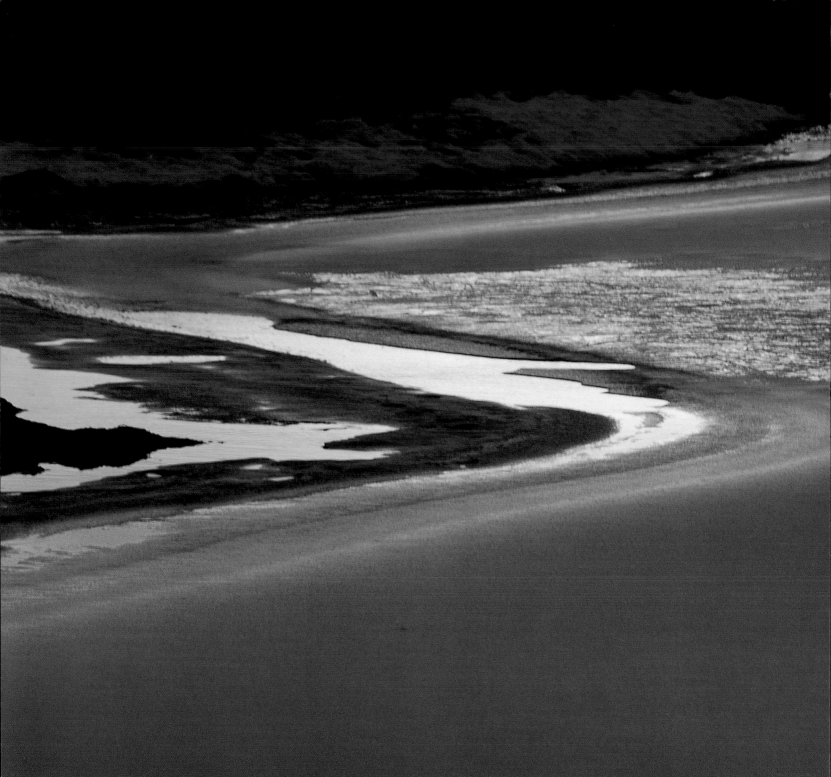

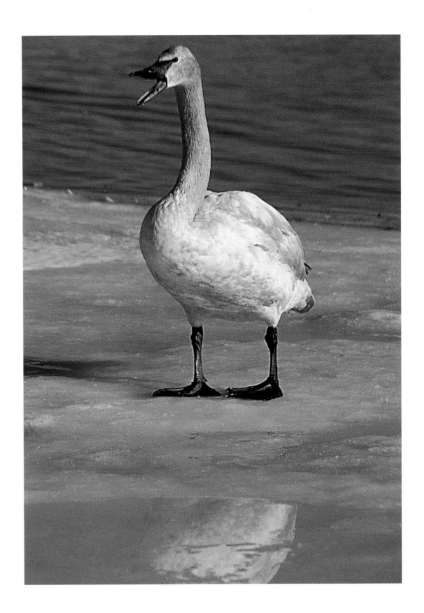

Above: Tundra swans pause their migration between the far north and the Chesapeake at the Great River Road outside Alton.

Left: Frozen sunset, Monroe County.

Right: Dawn enters downtown on the Chicago River, Chicago.

Below: Wildflowers enshrine a retired tractor rim.

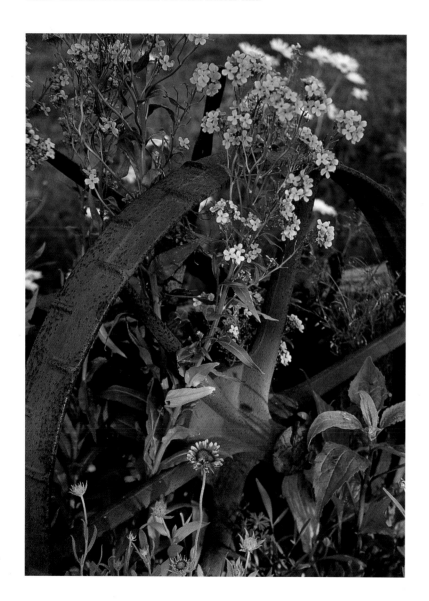

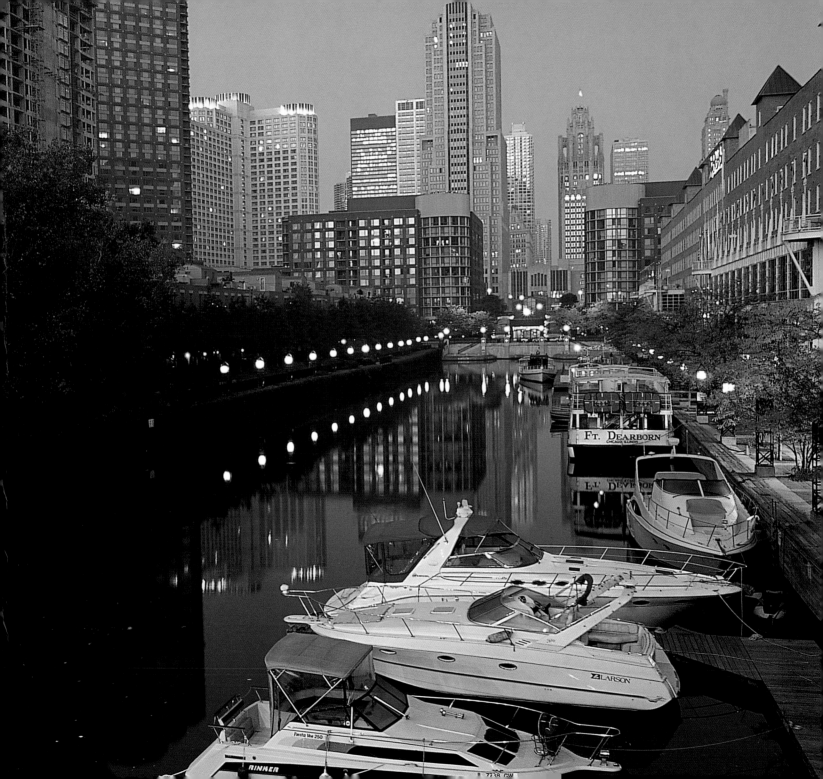

PHOTO BY RUTH HOYT

Scott R. Avetta is a native of St. Louis, Missouri, with a B.A. degree in business management. His work has been published in *Missouri Simply Beautiful, St. Louis—For the Record, Last Stand of the Tallgrass Prairie,* and *America's National Parks.*

He serves as a contributing photographer for *Missouri Life* magazine. National Audubon Society and other organizations have used his photographs for calendars, postcards, websites, and newsletters.

Scott teaches photography at the Missouri Botanical Garden and has been involved in photographic instruction for Kodak-sponsored workshops, the Missouri Department of Conservation, and Public Lands Day. He has photographed for nature-oriented organizations such as the Earth Day Celebration, the Open Door Sanctuary, and the World Bird Sanctuary.